A Child of Six Could Do It!

George Melly
J. R. Glaves-Smith

A CHILD OF SIX
COULD DO IT!

Cartoons about Modern Art

The Tate Gallery/Barron's

Contents

Foreword

This is a book of jokes about modern art which accompanies an exhibition on the same theme. Among all the ways in which we could have illustrated the way the astonishing transformations of art in the last seventy-five years have appeared to the public, we believe this is the most telling. The cartoons are often works of art in their own right and, as well as being funny, present a whole range of responses from the highly informed to the ignorant, from a fond amusement to an intense hatred. Some express an authentic criticism of the art and others only the prejudices of those who have not really looked.

This entirely unique exhibition, and this book, are offered as a strange but revealing mirror of the art which hangs in our galleries and in the other museums of modern art throughout the world.

Norman Reid Director

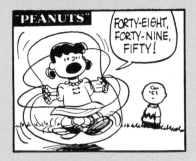

GEORGE MELLY

Jokes about Modern Art

Freud maintained that the main function of the joke was to 'economise on unconscious thought'. He believed that the sudden discharge of laughter releases us from inhibitions or anxieties at comparatively little expense. While questionable in relation to certain categories of joke (those based on exact social observation for instance), the theory would seem to explain others and among them the subject-matter of this exhibition; the astonishing persistence of visual jokes about 'modern art'.

From Romanticism on, each new movement has generated a surprisingly powerful reaction not only among academicians or subscribers to earlier schools but from the general public; a large proportion of whom were not interested in art in the ordinary way at all. Superficially this reaction may be put down to the generally held conviction, at any rate since the invention of photography, that the aim of the artist is to imitate nature as closely, that is to say as photographically, as possible. This leads on to the conclusion that those artists who fail to achieve this goal are either inept ('My little Johnnie could do better') or deliberately trying to hoodwink or cheat the public (The Emperor's New Clothes).

It's obvious, however, that the violence engendered by the various schools soon exhausted itself, fading away into either acceptance or indifference. The art critic Ian Dunlop has recently described this process in a book with the self-explanatory title *The Shock of the New**. Impressionism, for example, enraged the public because they had come to expect a degree of finish and were convinced, because they were used to the convention, that shadows were black. It didn't take all that long, however, before everybody could see 'like an Impressionist', but no sooner was this the case than the public were confronted with the apparently wilful distortions and arbitrary colours of Post-Impressionism, Expressionism and Fauvism and another howl of rage went up.

Yet neither the frustration of expectation nor the shock of unfamiliarity alone are enough to explain the intensity of the rage or hysterical laughter with which the key movements have been greeted. More profound is the conviction that art is somehow a basically moral activity, that somehow an assault on accepted visual standards masks an attack on moral standards. Nor is this view without foundation. In general, modernism in all its phases has to some degree challenged the conventional morality of its time and in some cases, Dada and Surrealism are the most obvious, has considered the function of art as no more than a visible projection of a moral stance. Yet even in instances where the artist conceived his function as aesthetic, Matisse for example, the public believed that the physical distortion, unrealistic use of colour and the flattening of the planes of perspective was a way of undermining an overall sense of reality in which physical and moral perception are in some way equated.

Running parallel to the public reaction, the cartoonists of each era have left behind them a humorous graph of the impact of the various phases of modern art. It is perhaps necessary to bear in mind that cartoonists, being themselves concerned with visual communication, may feel more involved than the lay public, but I don't

* Weidenfeld and Nicolson: £4·95.

think this to be of more than marginal importance. The body of the cartoons took as their subject matter those movements and, more particularly, those individual pictures or sculptures in front of which the public reacted most violently. To return to Freud's thesis by doing so they helped that same public 'economise on unconscious thought'.

There is, however, from the very beginning, a wide spectrum of reaction within the ranks of the cartoonists themselves. This ranges from affectionate pastiche to the most hostile rejection, from knowledgeable satire to ignorant misunderstanding. It's also worth underlining that with the passage of time, due no doubt to a general awareness of the direction of modern art, satirical sophistication has gradually gained ascendance over malicious approximation. Of late too, within the last five years or so, art as a subject for jokes has become less and less common. This is probably the result of several factors: the rapid absorption through television, reproductions in books and magazines, posters, record sleeves and so on, of the recent visual dialects; the decreasing effect of visual shocks due to a hundred years of exposure; the recent tendency of modern art to move towards the minimal or situationalist and the resultant difficulty of caricaturing a non-existent artifact.

In consequence this exhibition is taking place at the very moment when the tradition it represents is at an end. Within the whole there are several distinct tendencies and repetitive themes. I am going to try to define these and to investigate, where possible, their meaning or significance.

In selecting the comparatively small number of cartoons on exhibition from the enormous mass of relevant material, one of the first tendencies to become apparent was the way that certain individual images have been singled out by both public and cartoonists alike to personify each successive movement.

During Impressionism it was Manet's 'Olympia' which provided a target for ridicule. This however had little to do with Impressionism as such, indeed 'Olympia' was painted prior to the artist's conversion to Impressionist technique. What appalled the prurient French bourgeoisie of the third Empire was the painter's refusal to take advantage of the respectable convention of placing his nudes in a classical situation. It was Olympia's velvet neckband and contemporary shoes rather than her nudity which created the scandal and led, following Freud's dictum, to visual jokes which helped the outraged public 'economise on unconscious thought'.

During Post-Impressionism Matisse's 'La Dance' (No. 14) became the symbol of meaningless yet somehow corruptive distortion. At the New York Armory Show of 1913 the chosen icon was Marcel Duchamp's 'Nude Descending a Staircase' (Nos. 28, 29). Some of the resultant parodies were witty or at any rate mildly amusing, but it shouldn't be forgotten that the last laugh lay with that supreme ironist Marcel Duchamp himself.

While admittedly of local interest, Epstein's 'Rima' (Nos. 38–41) aroused both extraordinary hostility and innumerable cartoons at its expense when first sited in the bird sanctuary, Hyde Park. Epstein in general was considered 'a gift' to humorous artists but 'Rima', although by no means his most aggressive work, became the most popular target for attack.

Perhaps because it was already considered to be

a joke by most of the general public, Surrealism produced surprisingly few cartoons and what there were tended to reflect a certain sophistication (Nos. 49–55). In general terms only Dali's soft watches had a universal appeal (No. 51). On the other hand the holes in Henry Moore's reclining figures (Nos. 74–81) provided the most long-lived and frequently exploited butt for ridicule in the entire history of modern art.

Picasso invented an enormous number of astonishing images one might have predicted to have proved irresistible to cartoonists, especially as for many decades he was certainly the most famous modern artist, but perhaps in that he tended to avoid group shows and exhibited mainly in private galleries, perhaps because, until after the last war, he had held no large retrospectives, this was not the case. Not until the late forties, when those pictures he had painted during the German occupation were first exhibited, did his 'Woman with a fish-hat' become a widely exploited comic image (No. 58).

Looking at these images as a whole: Manet's 'Olympia', Matisse's 'La Dance', Duchamp's 'Nude Descending a Staircase', Epstein's 'Rima', Dali's 'Soft Watches', Moore's holes, Picasso's 'Woman with a fish-hat', I am struck by their confirmation of a not entirely unpredictable development in Freud's general theory as to the meaning of jokes; that is that much of the tension they help release is of a sexual origin.

Manet's nude (and come to that his earlier painting 'Le Déjeuner sur l'Herbe'), aroused anxiety because by placing them in a modern setting the artist prevented the spectator from distancing or concealing his feelings. Duchamp's nude, because if was unrecognisable *as a nude* caused frustration in that it *failed* to fulfil the promise of its provocative title. Matisse's 'La Dance', Epstein's 'Rima', both worried the public because their distortion of nudity appeared so aggressive as to threaten normal sexual response. Moore's holes, while touching on another area I shall be discussing later, have an obvious sexual significance. Dali's soft watches imply, as he was well aware, a symbolic impotence. The fish is an age-old penis symbol. Picasso's ferocious woman wears it on her hat, an image suggesting we are in the presence of a castrator flaunting the proof of her desexing of the male.

Following my impression that perhaps the most obsessive of the cartoons we selected were sexual in their latent meaning, the next most powerful revelation was how, affronted by certain images, the cartoonists reacted with surprising irrational violence. This particularly applies in the case of a number of cartoons relating modern art to the horrors of war and in this area so powerful are the emotions engendered that sensitivity and good taste are completely ignored.

Rodin for example was a popular general subject in his period, largely I suspect because of his lack of finish, but to allow one's irritation on this account to equate the mutilated victims of the Armenian atrocities with the sculptor's Impressionist technique (No. 12) is disturbing to say the least.

Less of a visual assault but no less unsympathetic in its implications is a *Punch* cartoon (No. 34) in which an officer and his mother are shown visiting an exhibition of Nevinson's Vorticist pictures of the trenches. The mother asks if they are an accurate representation of life at the front. Her son, whom we're told 'has seen terrible things in battle', answers her, 'Thank

heavens, no mother', he says grimly.

Most of the modern-art-equals-war cartoons are less extreme. In one a series of modern pictures with conventional titles fail to sell, but find ready buyers after they're renamed 'In the wake of the Huns', 'Ruin of a window in Rheims Cathedral', etc. Given the Futurists' delight in war this is unconsciously accurate, and one is reminded too of Picasso's comment on seeing the first camouflaged army truck in Paris in 1914 – 'We made that'.

Such accidental insight is by no means uncommon among the cartoonists and, perhaps because the only rein on the imagination is the need to be funny, many of the artists in lampooning one movement manage to predict later developments.

An art-nouveau designer, at work on the entrances to the Metro, is at a loss, but accidentally knocking over a bottle of ink, he is able to use the resulting squiggle to solve his problem (No. 8), and there are several other similar drawings in which Action Painting is foreseen (No. 10).

Another Rodin cartoon (No. 3) shows a series of formless lumps of flat stone on which are engraved the words 'Desire', 'Voluptuousness', 'Maturity' and 'Thought', an image which suggests certain word-pictures by Magritte.

In a *Punch* drawing of 1923 'An eminent Cubist marks out his tennis-court', but the white lines of a tennis court are much closer to Mondrian, then entirely unknown, than to any Cubist.

This cartoon also illustrates a further constant obsession: the idea that if only some practical use could be found for the work of modern artists they would become perfectly acceptable.

A Futurist sculpture is proposed as a scarecrow (No. 36). The string from a Moore is used to tie up a parcel (No. 76). It is, however, the reclining figures of Henry Moore which most exercise the imagination of the cartoonists in proposing to what use the holes might be put. Rival mobs of gangsters shoot it out through two parallel sculptures (No. 77). A small boy imagines, in a thought bubble, an elaborate model railway snaking its way through the holes and over the bumps and to illustrate the persistence of the belief that Moore's women ought to be put to some functional end we have included a recent newspaper photographer showing a workman using a large bronze as a combined couch and tea table.

Less extreme if, at the same time showing a certain obtuseness, are a number of cartoons which propose, as an absurd joke, that fashion decoration and furniture will eventually be affected by this or that avant garde movement (Nos. 32, 43). The fact that every earlier movement had immediately bled off into those very areas in no way prevented the cartoonists from believing that this time it couldn't possibly happen.

A more radical if constant theme is the reversal of reality and art, cubist people looking at realistic pictures or, as in the case of a recent Underground railway poster, a Picasso woman in a gallery full of old masters (Nos. 44, 52). At its best (in the work of Steinbeck for example) this caricaturing of the modern idioms can show true invention and understanding. Even when apparently the artist's only aim is to ridicule the accuracy and care with which the mannerisms are exaggerated show an underlying ambivalence. *Punch* might choose to rename Aubrey Beardsley, Daubry Weirdsley, but E.T. Reed's Beards-

leyesque 'Britannia' (No. 4) is both funny and painstakingly exact; as much a homage as an attack. The same applies to many of the cartoons lampooning art nouveau (Nos. 5–7). The subject matter may be unlikely but the treatment is perfectly respectful.

Inevitably we have felt forced to include some examples of the least inventive, most repetitive line of thought, that modern art must be the work of drunks, children, madmen or monkeys, that the pictures must be upside down, that primitives or cavemen must be responsible (Nos. 9, 83). Yet even in this exhausted field some artists, by an unexpected insight, have succeeded in finding something fresh to say. The academic chimp in evening dress with a glass of champagne in his hand at the private view says as much about the gallery world as about modern art, nor should it be forgotten that, in the tradition of modernism following the inventions of its detractors, the work of a chimpanzee, not to mention children and lunatics, has been exhibited.

The more recent movements, perhaps because of the public's growing sophistication, have attracted less attention, but where a cartoonist has thought of an idea the result, especially in *The New Yorker* is usually genuinely funny. Op Art copied from a television screen 'on the blink' is predictable but an unknown 'political prisoner' incarcerated inside an example of 'the geometry of fear', the Lichtenstein falling from the wall with a loud 'SNAP', 'BOP' and 'CRUNCH!', the irate neighbour shouting for the kinetic sculpture to be 'turned down', are all inventive and droll (Nos. 93, 102).

Another area in recent years which has attracted a great deal of malicious but witty attention is the tendency for artists to repeat themselves, especially those whose work appears, superficially at any rate, to verge on the simplistic (No. 96). The most recent cartoon in terms of the development of modern art is predictably from *The New Yorker*. A perplexed visitor enters an empty gallery. 'This *is* the show Madam' explains the owner (No. 114).

Political cartoonists too have occasionally used modern art usually as a way of lampooning chaotic or fragmented situations or politicians. Nevinson's 'Machine Gunners', the same picture that hung on the wall of the gallery where the officer and his mother expressed their bewilderment, appears more or less accurately in an attack on post-war taxation (No. 35). Lloyd George is transformed in a Surrealist personage (No. 54). Low, at the time of the 1936 Surrealist exhibition in London, adapted one of Magritte's images, 'The Endless Chain'. In Magritte's picture a Roman, a Renaissance man and a contemporary business executive are seated gazing impassively into the distance on the same horse. In Low's the horse is his own symbol for the T.U.C., an old dobbin, and the Trades Union officials on its back are in no such certainty as to which direction it should be heading.

The totalitarian system's well-known dislike of modernism yielded comparatively little material. The Russians suggest that the 'Bourgeois American formalists' paint their pictures with their feet, a scarcely devastating attack. Nazi Germany where, given Hitler's rabid loathing of modernism, you'd have expected a wealth of material was also on the thin side. Even the disputing mob of clay statues which the idealised Führer smashes up to remodel as a single noble Aryan look fairly traditional in their anatomy and proportions (No. 45). Strangely, given that the Nazis chose to

believe that modern art, like everything they proscribed, was the work of the Jews, we didn't come across any anti-modern art cartoon on this theme. Indeed the only example of an anti-Semitic nature was French.

It is perhaps instructive after visiting this exhibition to go directly into the Tate's modern rooms. Here are the paintings from the various schools which aroused so much scorn and laughter. They appear calm, convincing, classical, beyond dispute. It does us no harm, however, to remember that they were once the centre of such controversy but that it is the painters, and not those who tried to make them seem such crooks or fools, who have the last laugh.

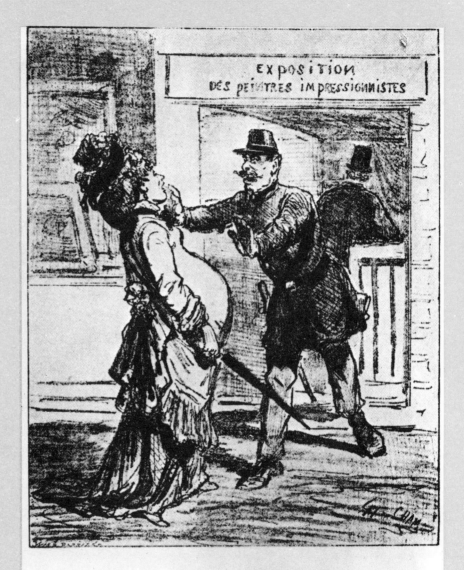

Policeman: "Lady, it would be unwise to enter!"
Caricature by Cham, published in Le Charivari
on the occasion of the third impressionist show,
1 *1877.*

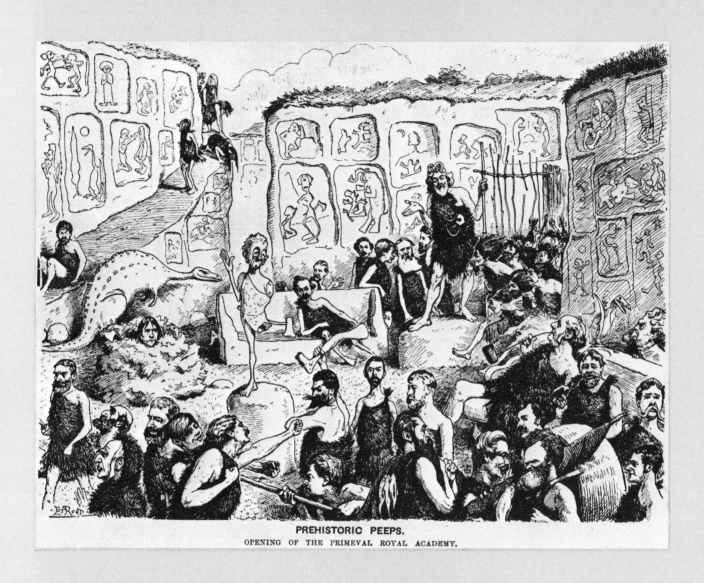

PREHISTORIC PEEPS.
OPENING OF THE PRIMEVAL ROYAL ACADEMY.

2 *Punch* 12 May 1894

[16]

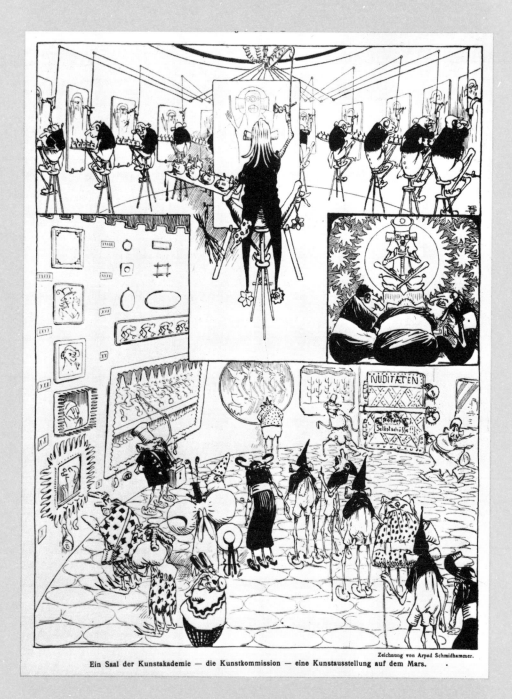

Zeichnung von Arpad Schmidhammer.

Ein Saal der Kunstakademie — die Kunstkommission — eine Kunstausstellung auf dem Mars.

3 *Jugend* 1896
A studio of the
Artschool –
The Arts Council –
an art exhibition on
Mars

BRITANNIA À LA BEARDSLEY.
(By Our "Yellow" Decadent.)

4 *Punch* 26 Nov. 1894 E.T. REED

5 *Punch* 1 Oct. 1894 E.T. REED

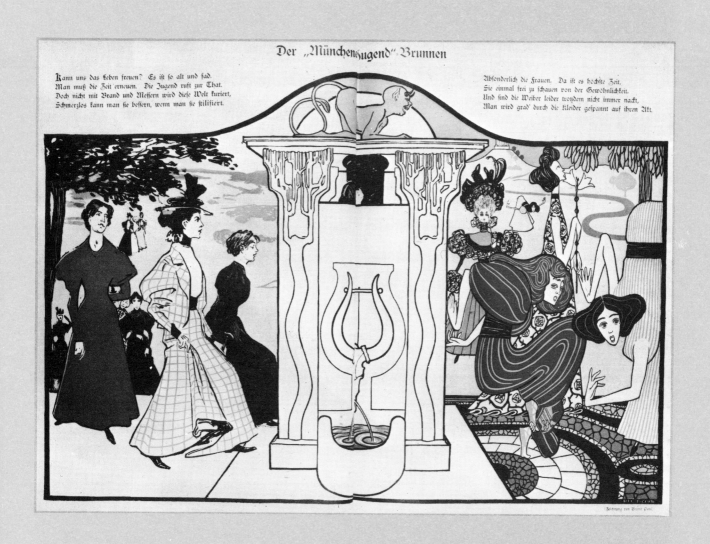

Der „Münchenzugend" Brunnen

Kann uns das Leben freuen? Es ist so alt und fad.
Man muß die Zeit erneuen. Die Jugend ruft zur That.
Doch nicht mit Brand und Messern wird diese Welt kuriert,
Schmerzlos kann man sie bessern, wenn man sie stilisiert.

Absonderlich die Frauen. Da ist es höchste Zeit,
Sie einmal frei zu schauen von der Gewöhnlichkeit.
Und sind die Weiber leider trotzdem nicht immer nackt,
Man wird grad' durch die Kleider gespannt auf ihren Akt.

6 *Simplicissimus* The Munich Fountain of Youth BRUNO PAUL

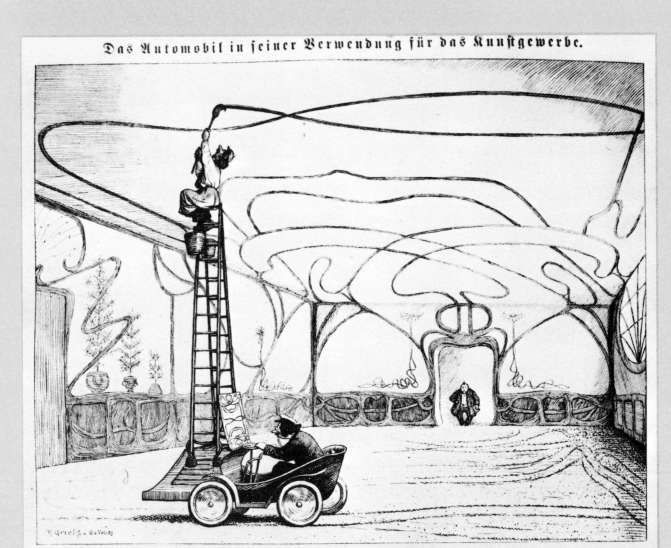

Bemalung des Plafonds eines großen modernen Saales.

7 *Fliegende Blatter* 12 June 1903 The use of the motor car in arts & crafts.
Painting the ceiling of a large modern room R. GREIFS

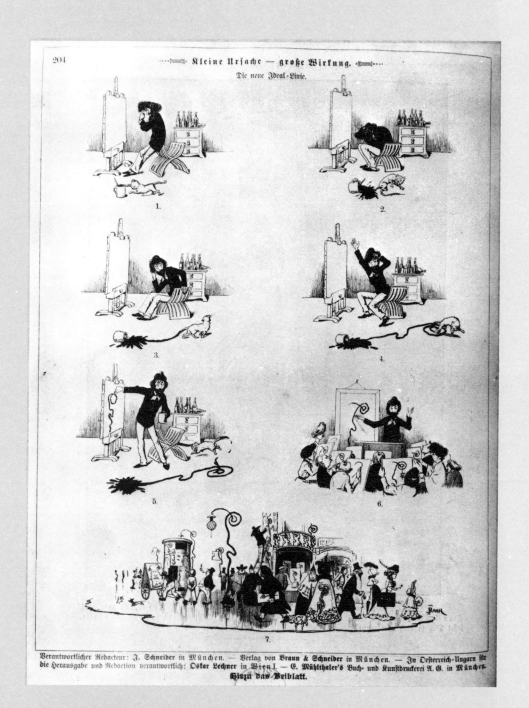

8 *Fliegende Blatter*
25 April 1902
Small cause great effect
The new ideal line
BAHR

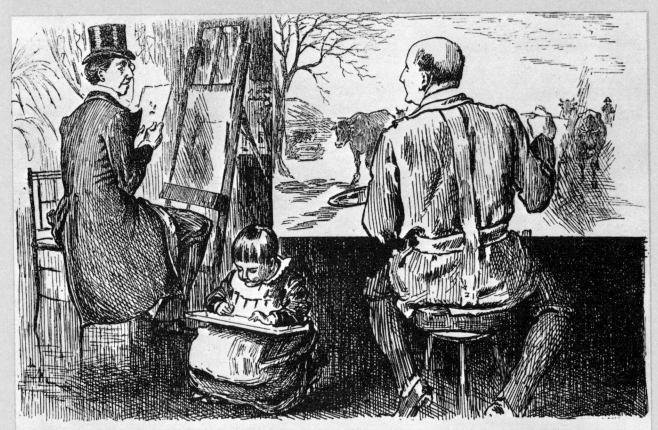

OUR DECADENTS.

Flipbutt (the famous young Art-Critic). "'Ullo! What's this Pencil Sketch I've just found on this Easel?"

Our Artist. "Oh, it's by Flumpkin—the Impressionist Fellow all you Young Chaps are so enthusiastic about you know. Clever, ain't it?"

Flipbutt. "Clever! Why, it's divine! Such freshness, such naïveté! Such a splendid scorn of mere conventional Technique! Such a——"

Our Artist. "'Ullo, Old Man! A thousand pardons! That's the wrong thing you've got hold of! That's just a Scribble by this little Scamp of a Grandson of mine. His first attempt! Not very promising, I fear; but he's only Four!"

10 *Charivari* 29 May 1910
At the Salon Nationale
Velasquez painted with large brushes.
The painter S. gave a public demonstration
of his new technique. Painting with a
palet knife being out of date he is
energetically promoting the use of the
fishing rod (for line) and the pistol 'to
put air into his pictures'.

A LA NATIONALE

Velasquez peignait avec de larges brosses.

Le peintre S... fait en public la démonstration de sa nouvelle technique. La peinture au couteau ayant fait son temps, il préconise énergiquement l'emploi de la canne à pêche (pour la ligne) et du pistolet « à mettre de l'air dans les tableaux ». Micolès.

11 *Fliegende Blatter* 2 Dec. 1898
More severe punishments.
Prosecution: I submit that the criminal, in
order to make his punishment more severe,
should have modern pictures hung in his
cell.

Straf-Verschärfung.
Staatsanwalt: „Ich beantrage, daß den Verbrechern, zur Verschärfung ihrer Strafe,

moderne Bilder in ihre Zelle gehängt werden!"

LA COMMISSION D'ENQUÊTE. — Oh ! les beaux modèles pour Rodin !..

12 *Le Charivari*
30 Nov. 1913
Balkan Atrocities
The Commission of
Enquiry – Oh!
What fine models
for Rodin!

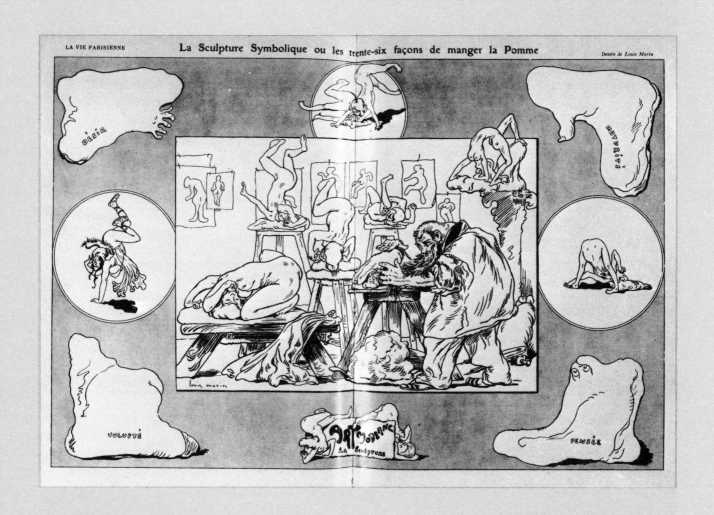

13 *La Vie Parisienne* 30 May 1908 Symbolic Sculpture or the 36 ways of eating an apple

HENRI MATISSE : *Avant.*

(Deux affiches pour vin constituant).

HENRI MATISSE : *Après.*

nous, bon public, de les avoir acceptées ainsi; sortons une fois pour toutes de la barbarie, il n'y a pas d'autre mot.

Je sais bien que cela empêchera les artistes d'envoyer autant de tableaux que par le passé. Mais qui s'en plaindra? Pas nous, bien sûr! Ni eux non plus, puisqu'ils trouveront leurs envois réduits, placés d'une façon qui fera gagner mille pour cent à leur talent! Tiens, par exemple, mon Loulou, tu n'appréciais pas beaucoup les dessins de Dethomas; tu trouves leur énergie lourde et charbonneuse... Eh! bien! va les voir dans la chambre qu'a délicieusement arrangée Baiguières, de chaque côté du lit à alcôve saumon, sur un fond de taffetas rayé de brun, et tu verras comme ils sont bien, et justes, et décoratifs...

Mais je ne t'ai pas assez bien expliqué peut-être qu'il y a cette année une masse de petites chambres, de boudoirs, de salons et de fumoirs qui se suivent.

METZINGER.
Encore un carreau de cassé!

Les peintres se sont mis à faire les tapissiers, les sculpteurs ont fait des meubles, les architectes ont dessiné des étoffes et des tapis. — Mais, Monsieur, c'est une émeute? — Non, Madame, c'est une Révolution!

Et pourquoi diable en effet les peintres, à qui nous accordons le don d'assembler des harmonies dans un cadre, ne seraient-ils pas les mieux capables de combiner les tonalités d'un appartement tout entier? Et pourquoi les sculpteurs seraient-ils moins indiqués pour modeler les courbes d'un buffet, que les biceps d'un gladiateur mourant sur une place publique?

ROETGER.
La première en-
travée cherchant
à marcher.

— Pourquoi? — On se demande vraiment maintenant où on avait la tête de n'y pas songer plus tôt, quand on voit le meuble où Marque, statuaire, a installé des médaillons d'enfants — il les fait mieux que personne — dans une armoire exquise signée d'un peintre. C'est le prince de Polignac qui aura cela, paraît-il. Heureux prince!

Pour mon compte, je mettrais bien dans mon cabinet de travail le beau poêle bleu où Süe, peintre de fleurs, s'est révélé incomparable fumiste, et je mangerais volontiers un petit œuf à la coque dans la salle à manger où Jaulmes, — un Indépendant, — a enfermé toute la brise du printemps. Mais on y mangera autre chose, je gage, car M. Charles Sterne n'est pas homme à se contenter d'une nourriture qui ne soit pas en mousse ou en turban.

Et c'est Madame, — dit-on toujours Ed-

Fécondité, par QUILLIVIC.
(Reproduction interdite).
(Statue pour la propagande malthusienne).

wards? — qui aura la chance de profiler sa beauté svelte et empanachée sur la tenture follement gris perle et rose de Bonnard. Et c'est M. Sterne encore qui aura l'avantage insigne de lire la cote de la Bourse entre les vierges florentines où Maurice Denis s'affirme définitivement notre plus grand décorateur de palais. Et c'est un marquis espagnol qui va s'offrir le luxe d'envoyer la fumée d'un cigare choisi aux petits derrières jambonnés des amours de M. José-Maria Sert voltigeant à travers les colonnades tiepolesques.

Est-ce que tout cela ne t'allèche pas, ma Louloute? T'en faut-il encore pour te décider à passer par-dessus tes respectables sentiments de famille et à prendre le rapide? Je te garde des surprises : la chambre arrangée par Groult, propre beau-frère de ton cher, très cher Poiré, et la dernière folie furieuse de Matisse dans le genre vermillon et vert véronèse pur, et les Laprade, et les Bourdelle, et les Galtier-Boissière, et les du Gardier, et les Maillol, et les Drésa, sans excepter le Persée de Valloton qui met un crocodile à la broche sur les bords du lac de Genève.

Mon Dieu! Voilà que j'oublie encore les Munichois. Ils prennent pourtant assez de place et ils ont dépensé assez d'argent! C'est très intéressant, très, très... On ne peut pas dire autrement. Moi pourtant je mourrais de spleen dans leur appartement garni, mais personne ne nous demandera d'y demeurer, n'est-ce pas! Heureusement! parce que la chambre de Madame a un lit trop court, style Napoléon III par-dessus le marché, et que celle de Monsieur est au ripolin blanc, depuis le plafond jusqu'aux pieds de la table de nuit. Tu vois d'ici cette horreur virginale!

D'ailleurs, tout ce qui ressemble à un lit ou seulement à un canapé me tourne le cœur depuis que tu es à la campagne.

Ton
DORILAS

OTHON FRIESR.
Pauvre pêcheur!

Bluettes

La jalousie, chez l'homme, c'est la crainte d'être trompé; chez la femme, c'est l'horreur d'être devancée.

❧

La parole a été donnée à l'homme pour économiser sa pensée.

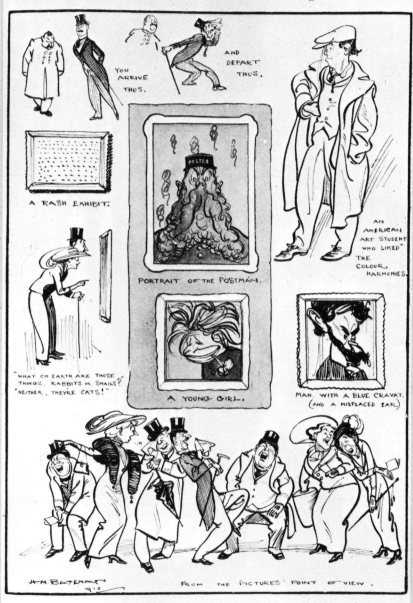

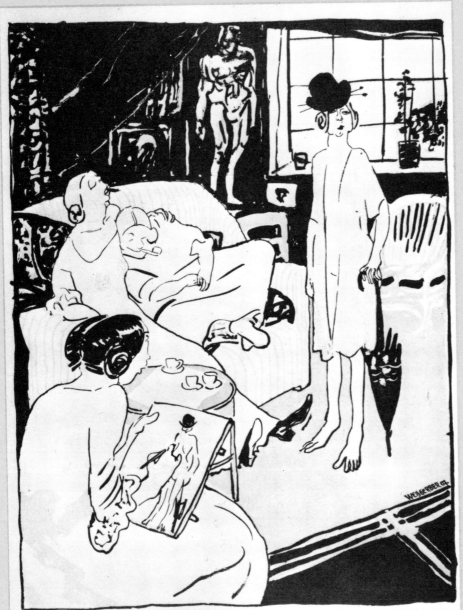

Die Ehe als Kunstwerk Albert Weisgerber (München)

„Was macht Hans Joachim Wellenkamp jetzt?" — „Der ist in einer Bankiers-Ehe künstlerischer Beirat!"

16 *Jugend* 1910
(Alfred Scherz Verlag)
Marriage as a work of art
'What's Hans Joachim
Wellemkamp doing ?'
'He is art-adviser to a
banker's marriage.'

17 *Fliegende Blatter*
28 Feb. 1913
'Is that supposed to
be me ?'
Painter: 'Certainly, its
your inner portrait.'
EUGENE KIRCHNER

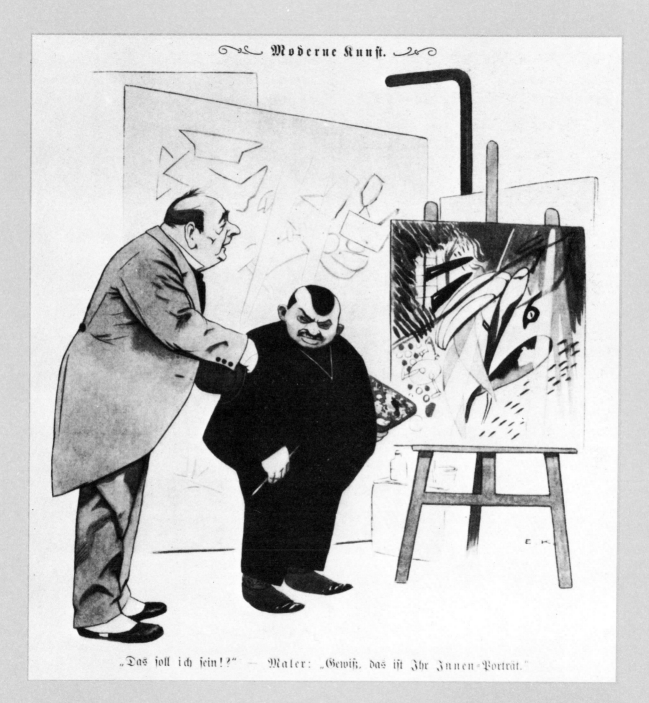

Moderne Kunst.

„Das soll ich sein!?" — Maler: „Gewiß, das ist Ihr Innen=Porträt."

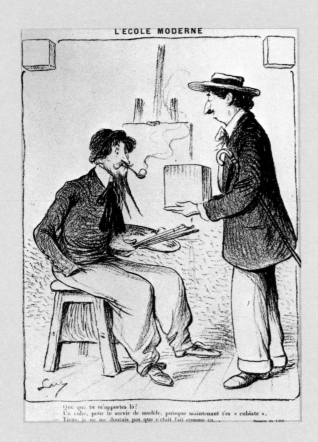

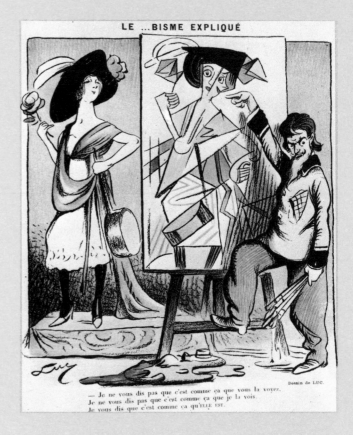

18 *Journal Amusant* 28 Oct. 1911
The Modern School
'What are you bringing me?'
'A cube as a model since you are now a cubist.'
'Well! I never thought it was done like that.'

19 *Journal Amusant* 9 Nov. 1912
...ism explained
I don't say that is how *you* see her
I don't say that is how *I* see her
I say that is how *she is*
LUC METIVET

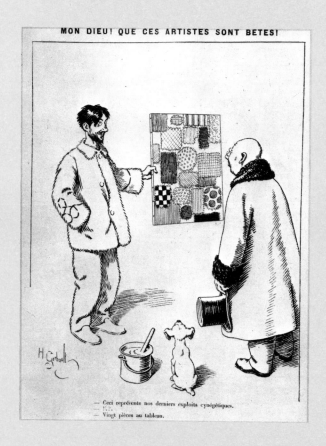

20 *The Masses* April 1913
JOHN SLOAN

21 *Journal Amusant* 18 April 1914
My God! What animals painters are
'This represents our latest hunting works.'
'!?'
'Twenty pieces in one picture.'
H. GERBAULT

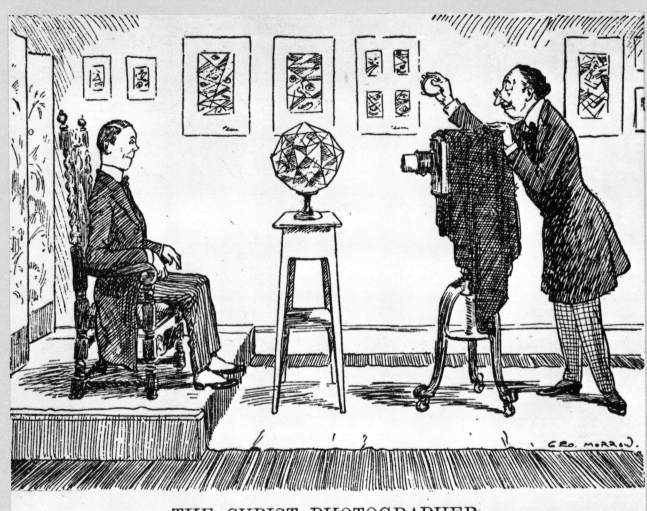

THE CUBIST PHOTOGRAPHER.

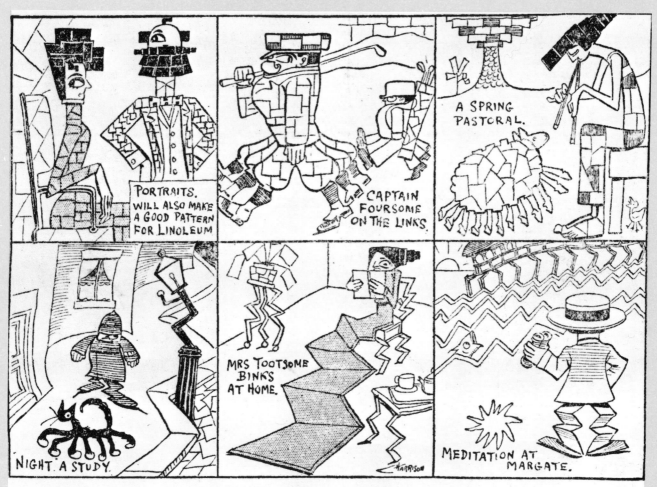

THE NEW TERROR.

The one-eyed art of the "Futurists," and its probable influence on modern painters.

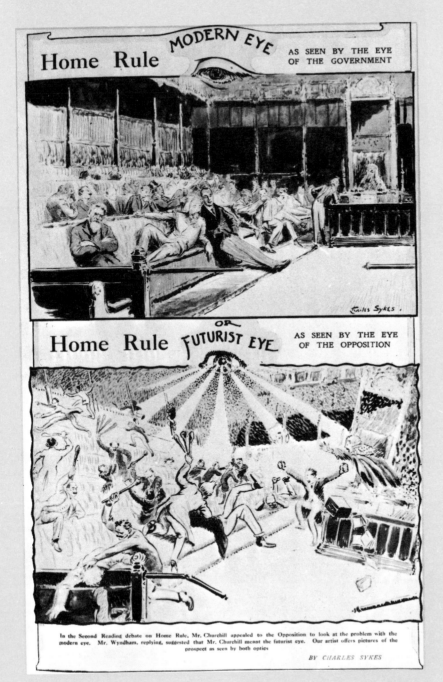

24 *Bystander* 22 March 1912

25 *Journal Amusant* 2 March 1912
This is the most completely futurist
picture: it is only signed now and I will
never paint it
LUC METIVET

— C'est un tableau tout ce qu'il y a de plus « futuriste » : il n'est encore que signé, et je ne le peindrai jamais.

Dessin de LUC.

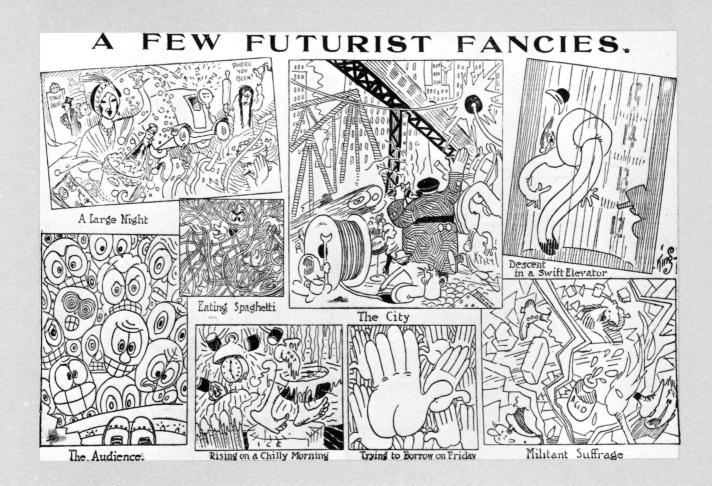

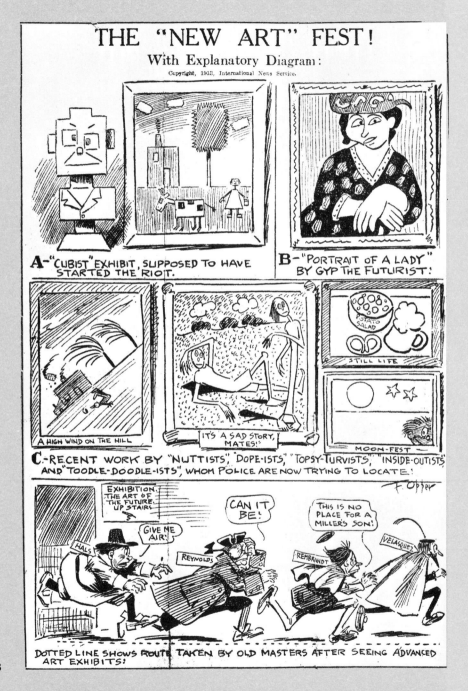

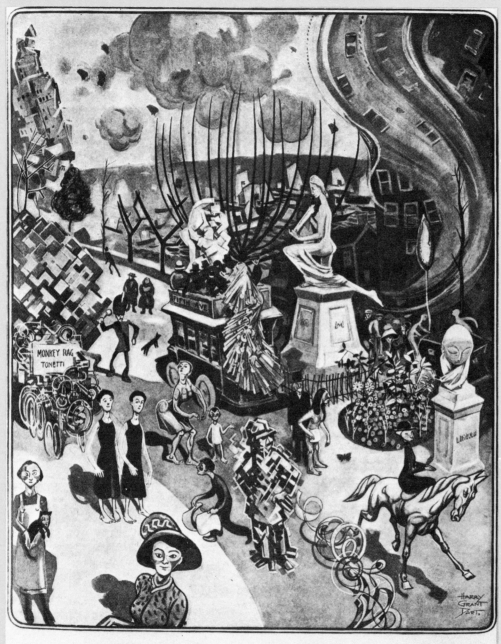

BEAUTIFUL NEW YORK MADE POSSIBLE BY THE NEW ART

28 *Life* 20 March 1913

SEEING NEW YORK WITH A CUBIST

The Rude Descending a Staircase
(Rush Hour at the Subway)

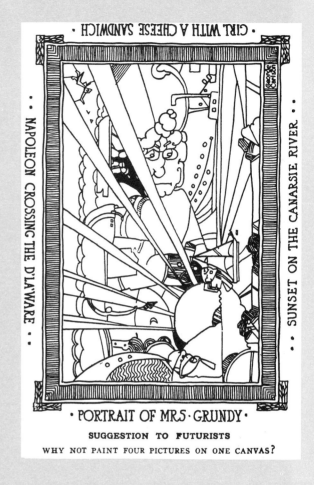

GIRL WITH A CHEESE SANDWICH

NAPOLEON CROSSING THE D'LAWARE

SUNSET ON THE CANARSIE RIVER

· PORTRAIT OF MRS · GRUNDY ·

SUGGESTION TO FUTURISTS
WHY NOT PAINT FOUR PICTURES ON ONE CANVAS?

29 20 March 1913

30 *Life* 8 May 1913

MANDEL BROTHERS

Influence of cubist art on the new gowns, wraps, hats, silks, etc.,

gives unmistakable expression in the more daring foreign models, patterns, etc., most lately added to our spring exhibits.

In view of the much talked of exposition of futurist and cubist pictures and marbles at the Art Institute, this week, still more notable and still more interesting is our contemporaneous display of the first "cubistic fashions."

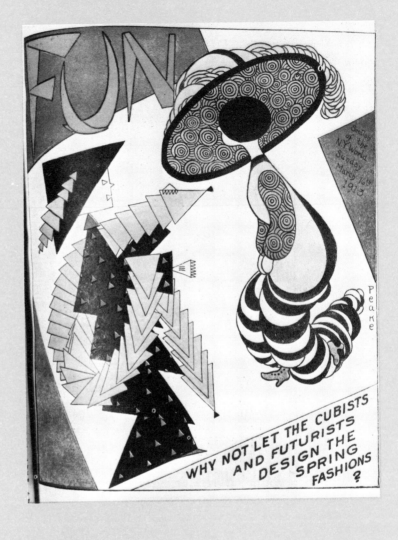

31 *Chicago Tribune* 24 March 1913
Advertisement

32 *World* 16 March 1913

33 *Simplicissimus* 1916 At the Futurist Show OLAF GULBRANSSON

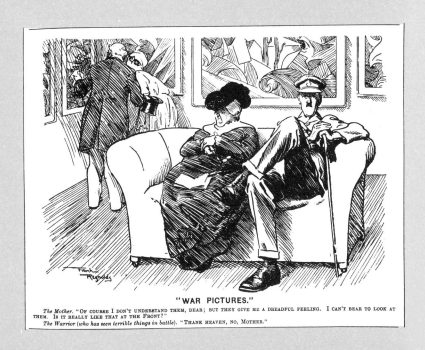

"WAR PICTURES."

The Mother. "OF COURSE I DON'T UNDERSTAND THEM, DEAR; BUT THEY GIVE ME A DREADFUL FEELING. I CAN'T BEAR TO LOOK AT THEM. IS IT REALLY LIKE THAT AT THE FRONT?"
The Warrior (who has seen terrible things in battle). "THANK HEAVEN, NO, MOTHER."

34 *Punch* 31 July 1918

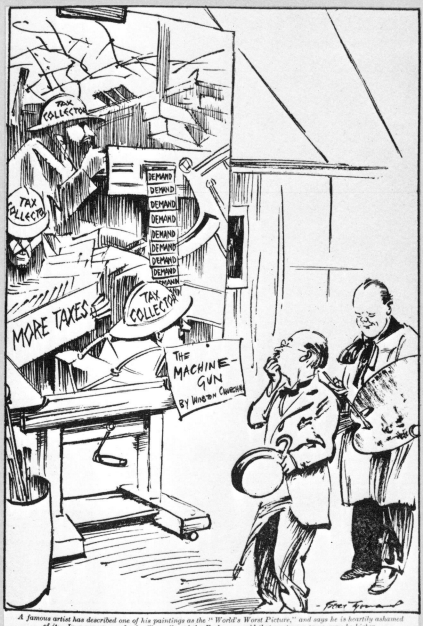

A famous artist has described one of his paintings as the "World's Worst Picture," and says he is heartily ashamed of it. In a recent speech, the Chancellor of the Exchequer said that next year taxes may be higher.

"THE WORLD'S WORST PICTURE."

MR. TAXPAYER: "I THINK IT'S SIMPLY DISGUSTING. YOU OUGHT TO BE HEARTILY ASHAMED OF IT!"

35 *London Opinion* 7 Nov. 1925

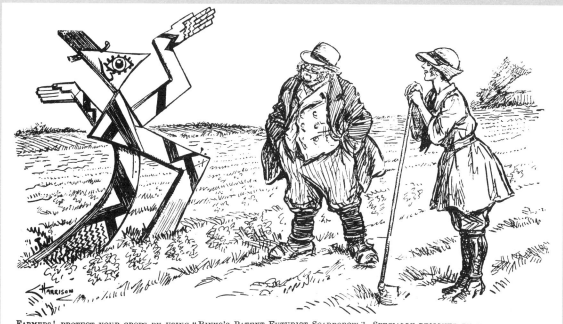

FARMERS! PROTECT YOUR CROPS BY USING "BINKS'S PATENT FUTURIST SCARECROW." SPECIALLY DESIGNED BY AN EMINENT CUBIST. NO BIRD HAS EVER BEEN KNOWN TO GO WITHIN THREE FIELDS OF IT.

36 *Punch* 17 July 1918

Charlady. "THAT'S JUST 'OW YOUR 'USBAND SEES 'EM? AH, MY OLE MAN SEES THINGS LIKE THAT, BUT THANK 'EVIN 'E DON'T DRORE 'EM."

37 *Punch* 10 Oct. 1923

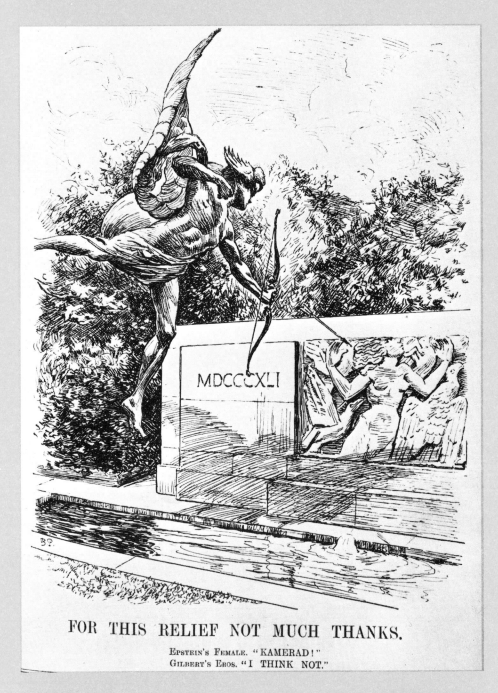

MDCCCXLI

FOR THIS RELIEF NOT MUCH THANKS.

EPSTEIN'S FEMALE. "KAMERAD!"
GILBERT'S EROS. "I THINK NOT."

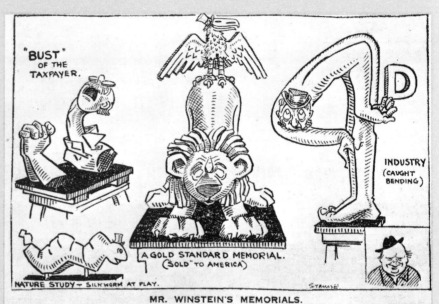

"BUST" OF THE TAXPAYER.

A GOLD STANDARD MEMORIAL. ("SOLD" TO AMERICA)

INDUSTRY (CAUGHT BENDING)

NATURE STUDY — SILKWORM AT PLAY.

MR. WINSTEIN'S MEMORIALS.

Inset shows Mr. Winstein, who says he's quite satisfied with his work, and doesn't care what the critics think.

39 *Daily Express* 22 May 1925

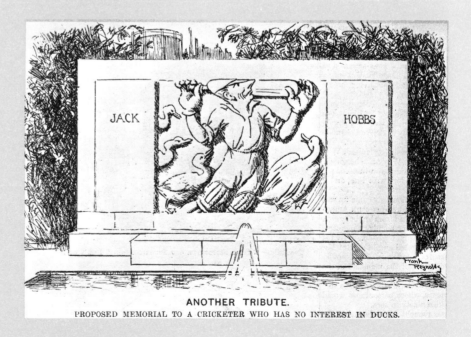

JACK HOBBS

ANOTHER TRIBUTE.
PROPOSED MEMORIAL TO A CRICKETER WHO HAS NO INTEREST IN DUCKS.

40 *Punch* 24 June 1925

PIP, SQUEAK AND WILFRED

No. 190.—PIP'S WONDERFUL "STATUE" OF AUNTIE DESTROYED BY ANGRY "CRITICS"

1. Pip was missing for several hours yesterday morning, so Squeak went in search of him.

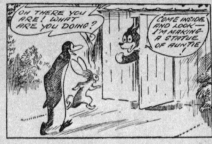

2. At last she discovered him in the tool-shed. "Come in," said Pip, "and see my statue."

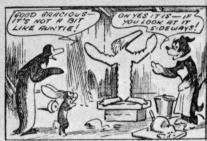

3. "There you are," he said, pointing to an extraordinary looking object. "It's a statue of Auntie!"

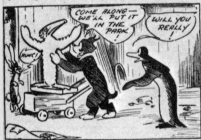

4. "What big, ugly flappers she has," said Squeak. "And what an awfully long nose!"

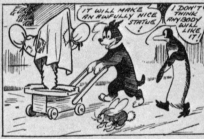

5. Pip, however, said it was a splendid "statue," and took it off to the park.

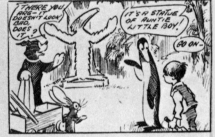

6. "There you are," he said, as he "unveiled" the queer-looking figure. "What could be nicer?"

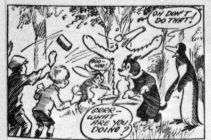

7. However, numbers of children who appeared said the statue was simply awful, and before long—

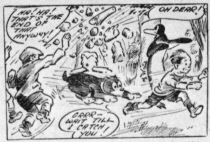

8. —they were pelting it with stones and mud as if it had been an "Aunt Sally"!

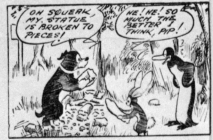

9. The wonderful "statue" was smashed to pieces. Nobody, except Pip, will feel particularly sorry.

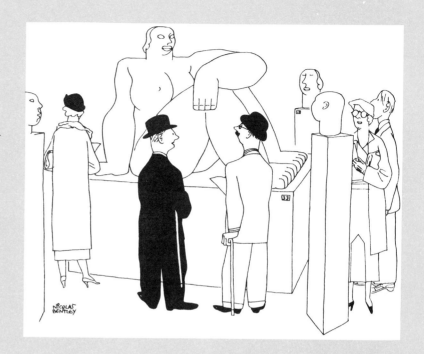

42 *Bystander*
'My Aunt!'
'Not really?'

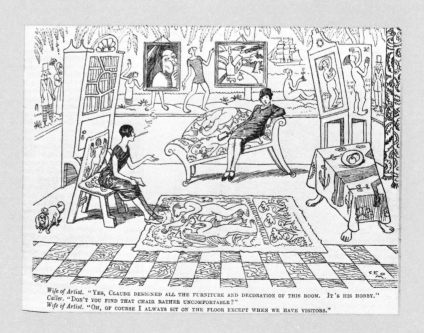

Wife of Artist. "YES, CLAUDE DESIGNED ALL THE FURNITURE AND DECORATION OF THIS ROOM. IT'S HIS HOBBY."
Caller. "DON'T YOU FIND THAT CHAIR RATHER UNCOMFORTABLE?"
Wife of Artist. "OH, OF COURSE I ALWAYS SIT ON THE FLOOR EXCEPT WHEN WE HAVE VISITORS."

43 *Punch* 30 June 1926 GEORGE MORROW

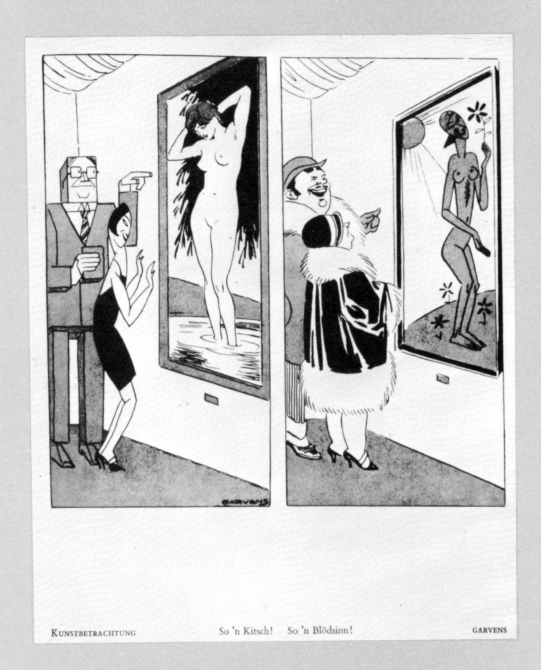

KUNSTBETRACHTUNG So 'n Kitsch! So 'n Blödsinn! GARVENS

44 *Die Deutsche in seine karikaturs* Attitudes to Art 'How corny' 'How rubbishy'

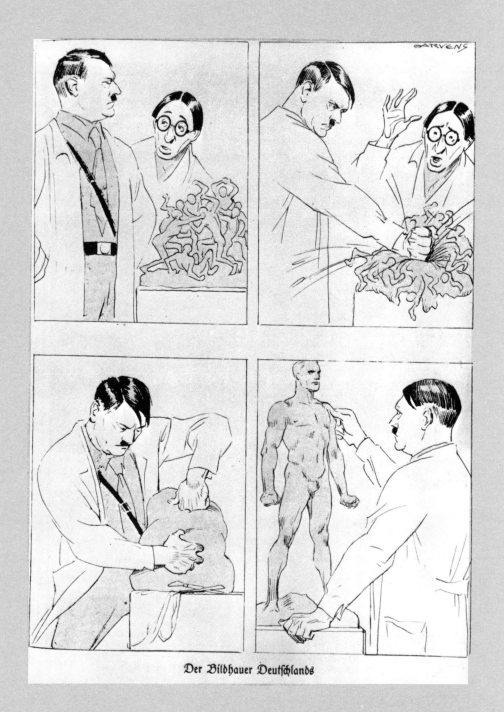

Der Bildhauer Deutschlands

45 *Jugend* 1933
The Sculptor of
Germany

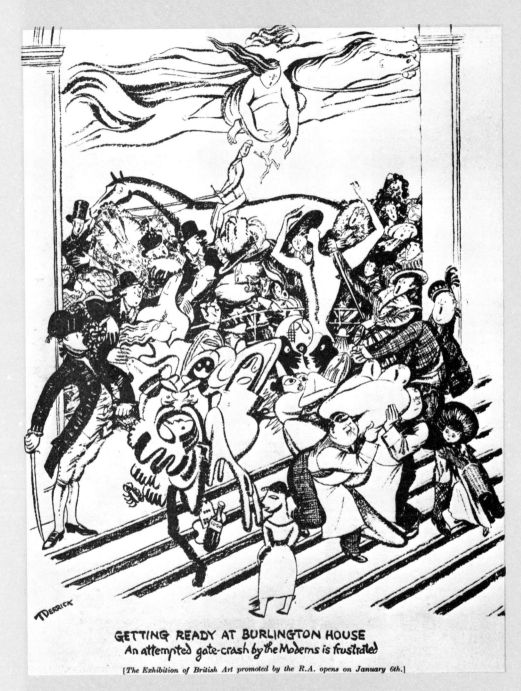

GETTING READY AT BURLINGTON HOUSE
An attempted gate-crash by the Moderns is frustrated

[*The Exhibition of British Art promoted by the R.A. opens on January 6th.*]

46 *Punch* 3 Jan. 1934

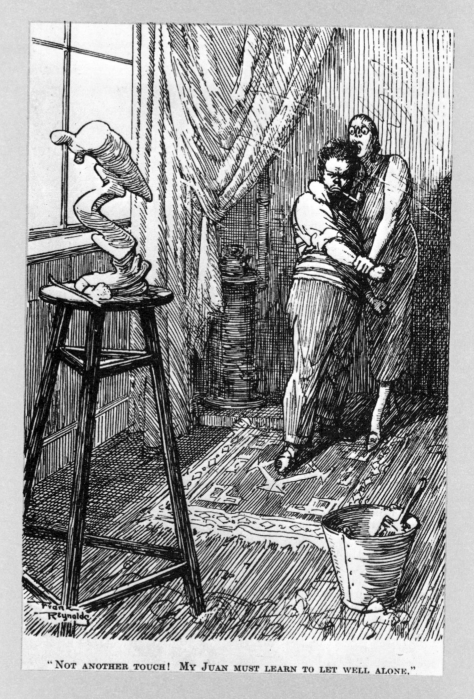

"NOT ANOTHER TOUCH! MY JUAN MUST LEARN TO LET WELL ALONE."

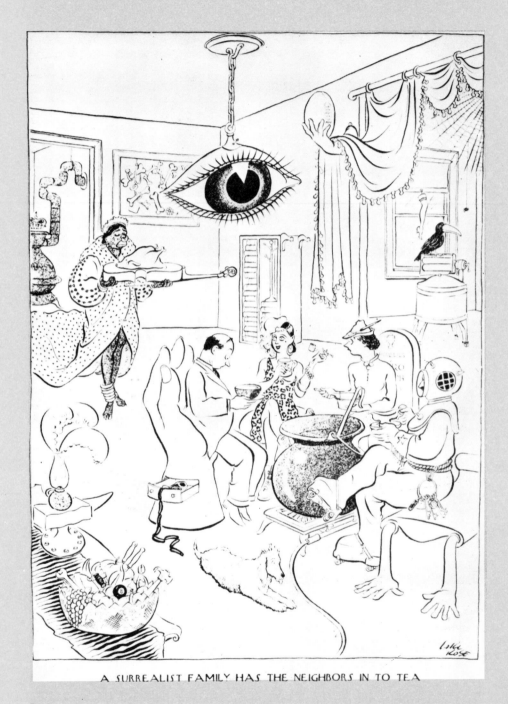

A SURREALIST FAMILY HAS THE NEIGHBORS IN TO TEA

48 *New Yorker Album* 1937
CARL ROSE © 1937

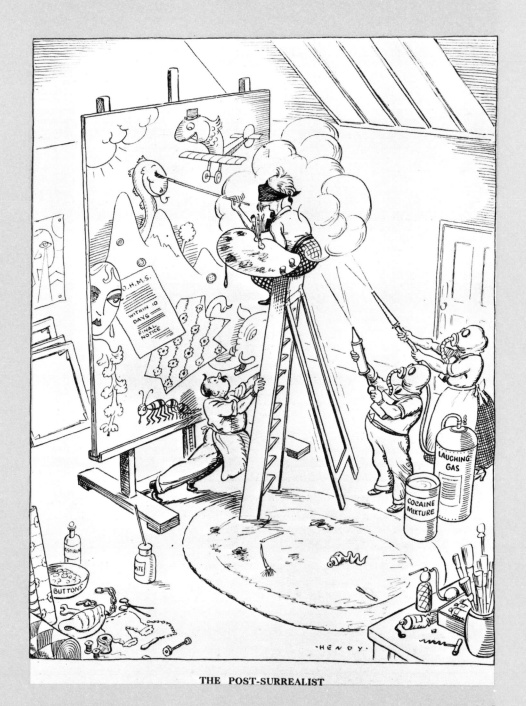

THE POST-SURREALIST

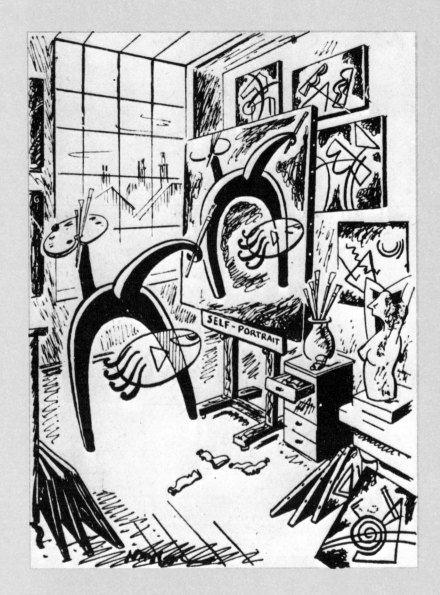

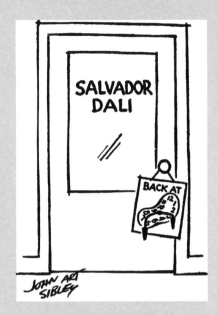

50 *Lilliput* Oct. 1943 HAYLAND

51 *Strand* June 1946

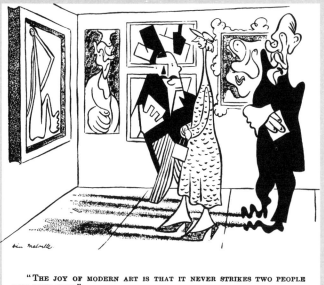

"THE JOY OF MODERN ART IS THAT IT NEVER STRIKES TWO PEOPLE THE SAME WAY."

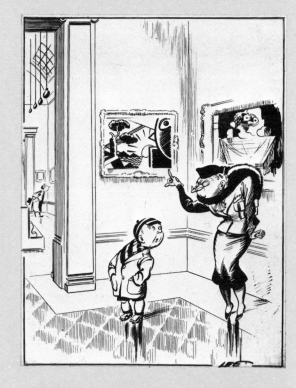

52 *Punch* 9 Nov. 1938

53 *Evening News c.* 1936
Associated Newspapers Group Ltd
London Laughs: Modern rooms, Tate Gallery.
'Willy! Did you do that?'

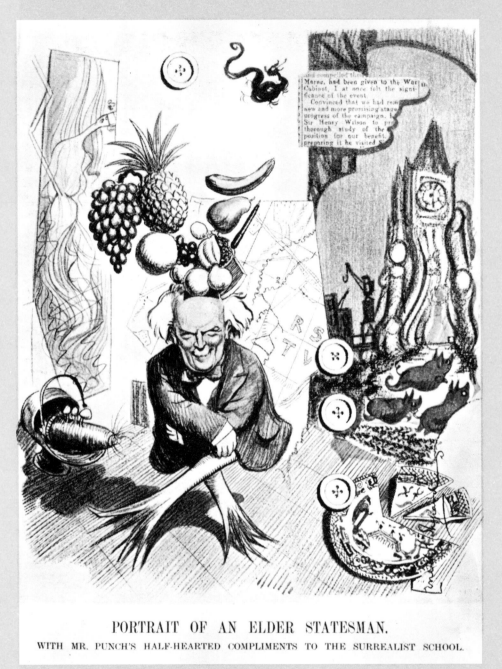

PORTRAIT OF AN ELDER STATESMAN.

WITH MR. PUNCH'S HALF-HEARTED COMPLIMENTS TO THE SURREALIST SCHOOL.

54 *Punch* 8 July 1936
ERNEST H. SHEPARD

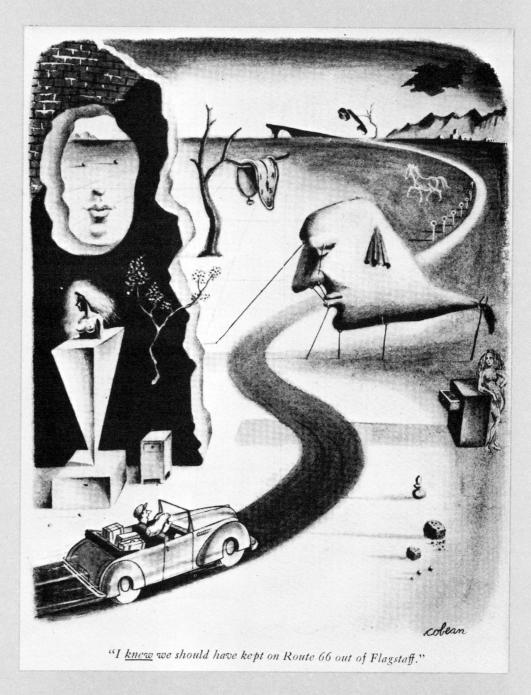

"I *knew* we should have kept on Route 66 out of Flagstaff."

55 *New Yorker*
13 Sept. 1947
COBEAN © 1947

56 *Facades & Faces*
John Murray 1950
OSBERT LANCASTER

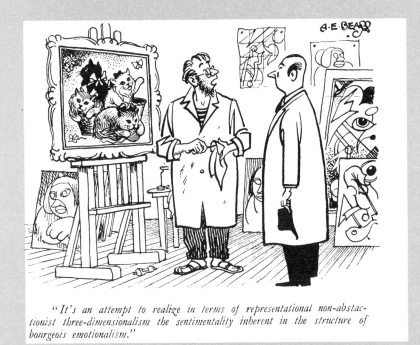

"*It's an attempt to realize in terms of representational non-abstactionist three-dimensionalism the sentimentality inherent in the structure of bourgeois emotionalism.*"

57 *Punch* 15 Oct. 1952

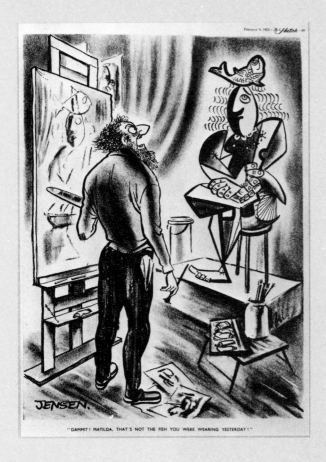

"DAMMIT! MATILDA, THAT'S NOT THE FISH YOU WERE WEARING YESTERDAY!"

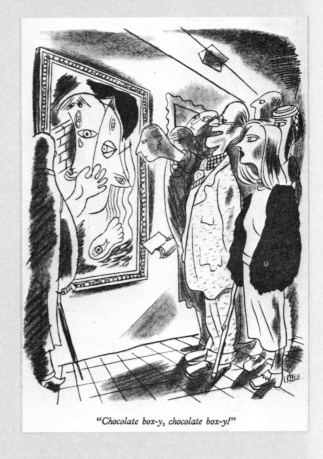

"Chocolate box-y, chocolate box-y!"

58 *Sketch* 9 Feb. 1955 Associated Newspapers Group **59** *Lilliput* June 1946

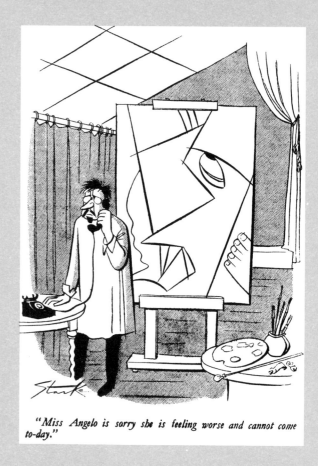

"Miss Angelo is sorry she is feeling worse and cannot come to-day."

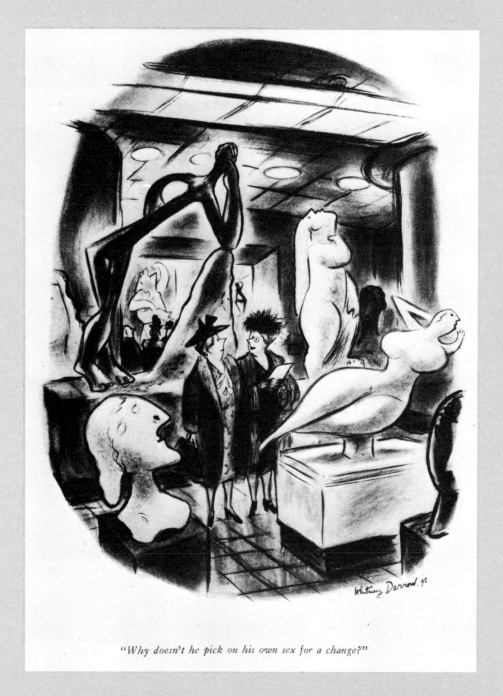

"Why doesn't he pick on his own sex for a change?"

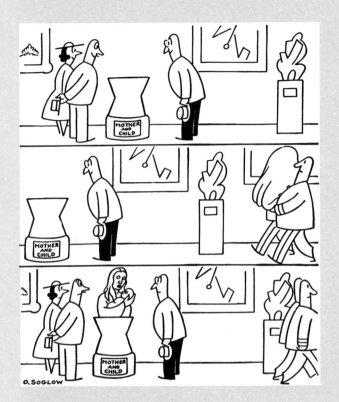

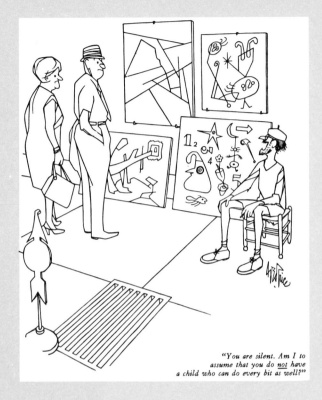

"You are silent. Am I to
assume that you do _not_ have
a child who can do every bit as well?"

63 *New Yorker* 23 July 1955
O. SOGLOW © 1955

64 *New Yorker Art & Artists album*
GEORGE PRICE © 1970

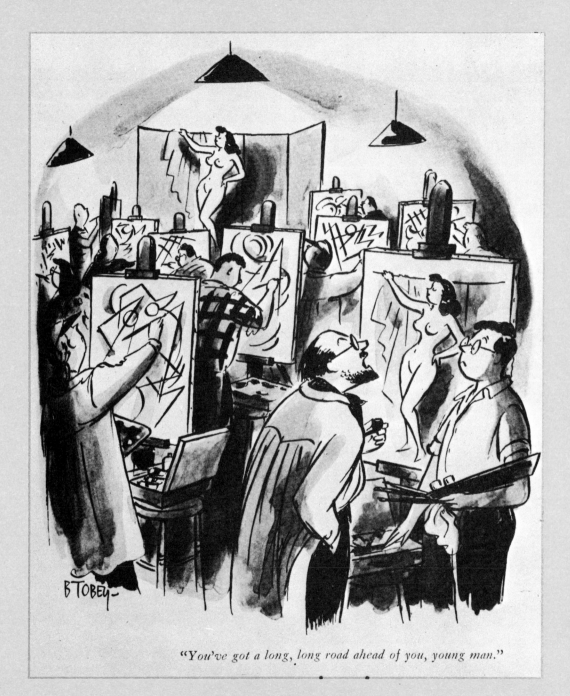

65 *New Yorker*
15 Dec. 1951
B. TOBEY © 1951

"*You've got a long, long road ahead of you, young man.*"

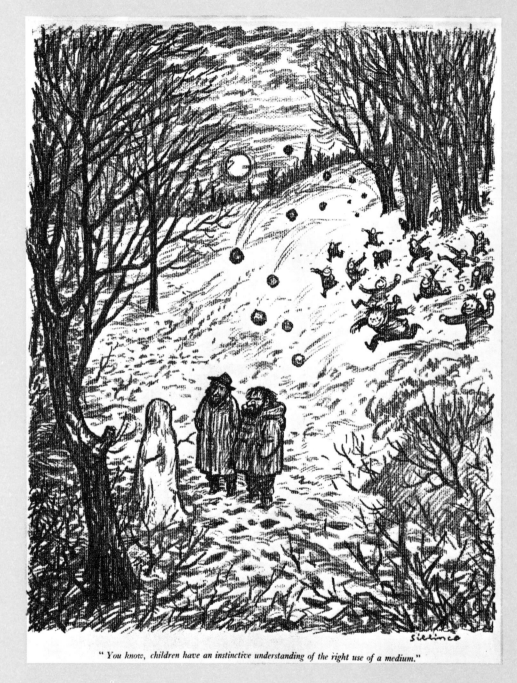

"*You know, children have an instinctive understanding of the right use of a medium.*"

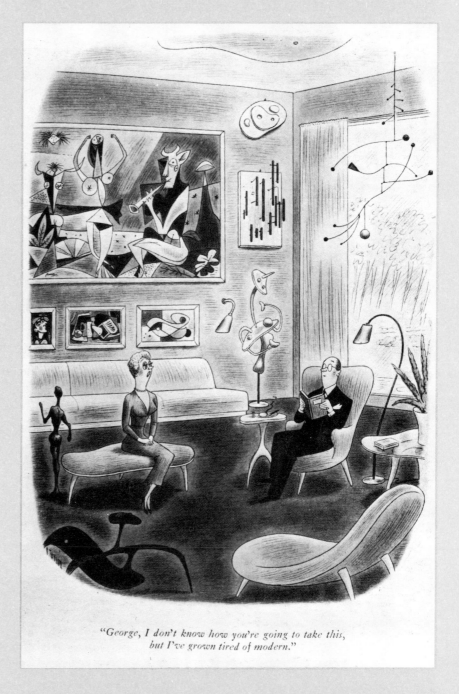

"George, I don't know how you're going to take this,
but I've grown tired of modern."

67 *New Yorker* 22 July 1950
R. TAYLOR © 1950

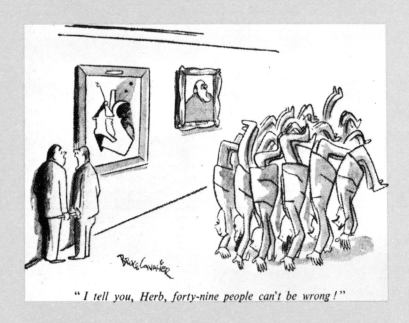

"I tell you, Herb, forty-nine people can't be wrong!"

68 *London Opinion* Jan. 1953

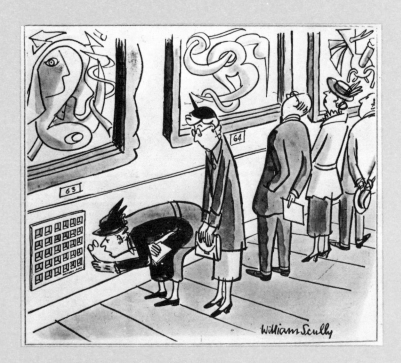

69 *Sketch* 7 May 1952
Associated Newspapers Group Ltd
'It says "Air Conditioning by Ajax".'

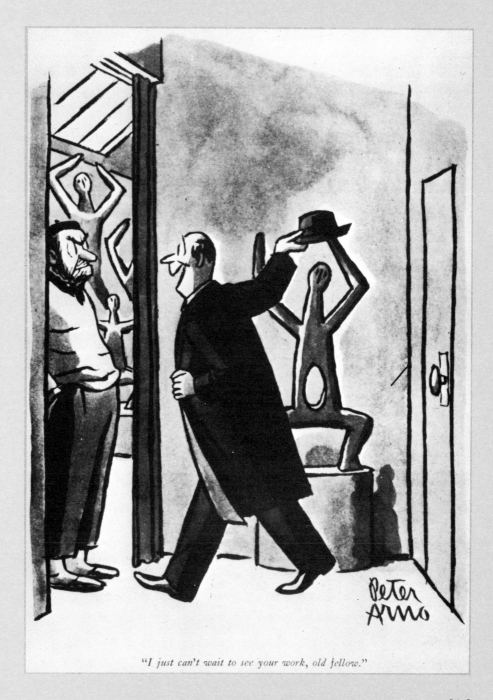

"I just can't wait to see your work, old fellow."

70 *New Yorker*
26 Dec. 1953
PETER ARNO © 1953

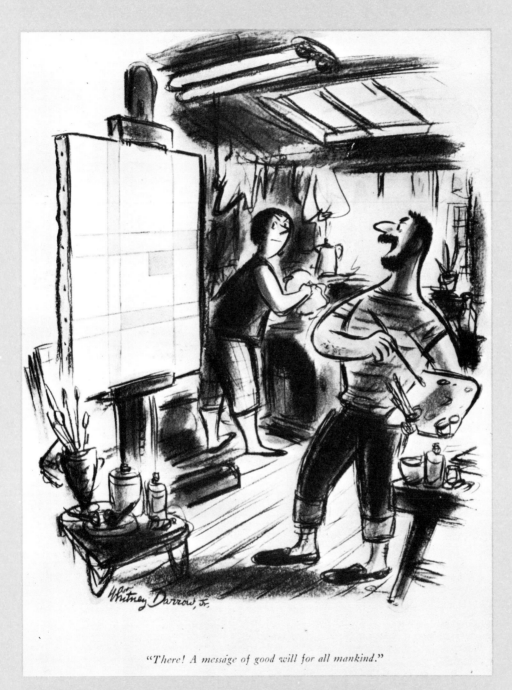

"There! A message of good will for all mankind."

71 *New Yorker*
19 Feb. 1955
WHITNEY DARROW JR.
© 1955

72 *New Yorker* 14 Nov. 1953 STEINBERG © 1953 73 *Punch* 18 July 1951

74 *Punch* 2 Dec. 1952

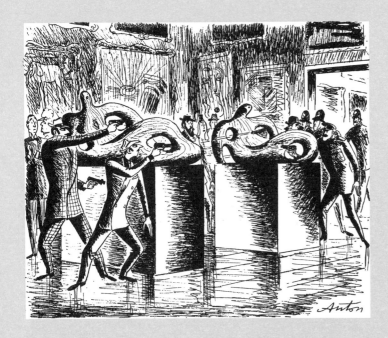

75 *Punch* 12 Nov. 1947

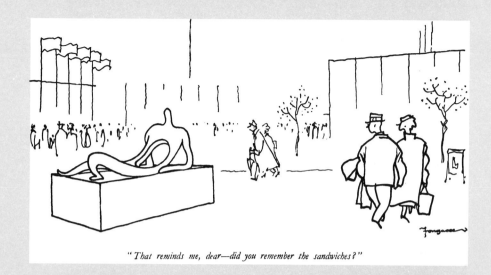

76 *Punch* 27 June 1951

"That reminds me, dear—did you remember the sandwiches?"

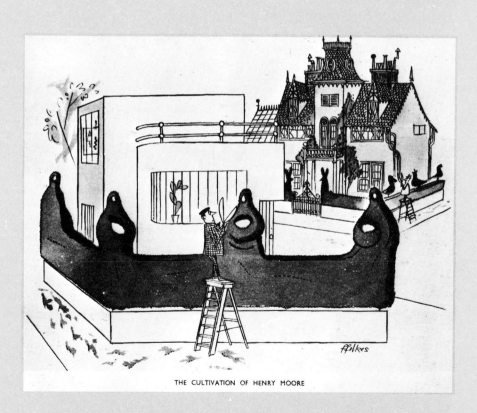

THE CULTIVATION OF HENRY MOORE

77 *Sketch* 16 July 1952
Associated Newspapers Group Ltd

78 *New Yorker Art &*
Artists album
SOGLOW © 1970

79 *Punch* 16 July 1958
THELWELL

80 *New Yorker* 3 Nov. 1951
B. WISEMAN © 1951

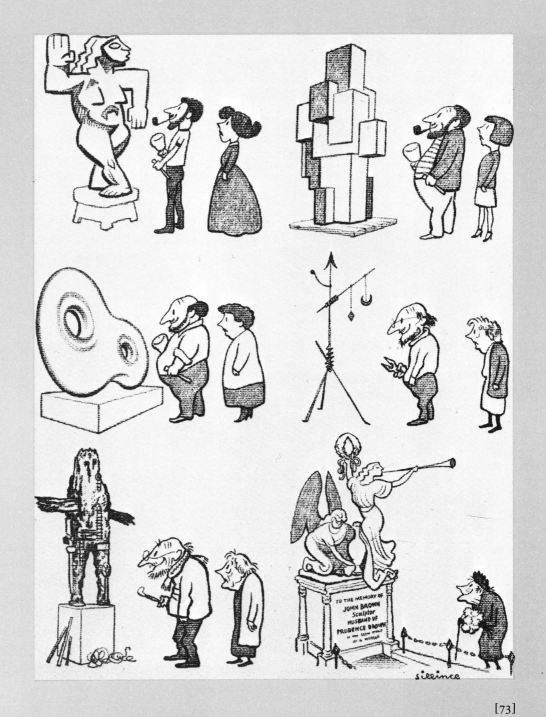

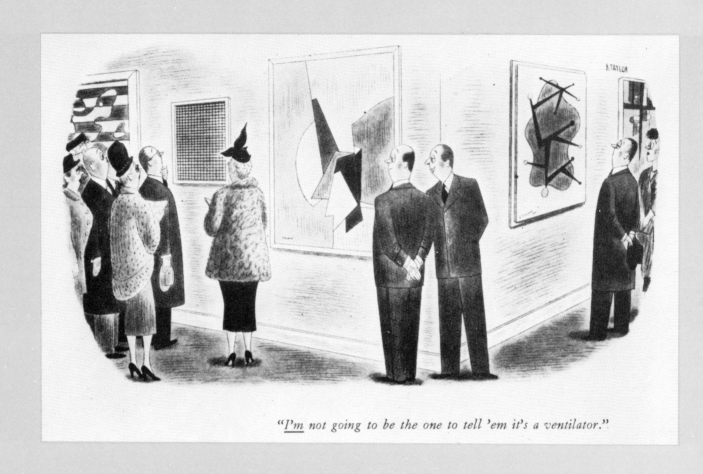

"*I'm not going to be the one to tell 'em it's a ventilator.*"

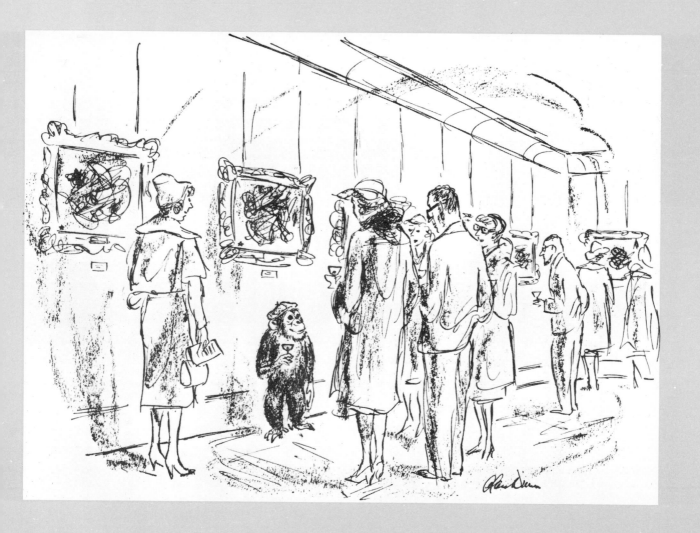

83 *New Yorker Art & Artists album* ALAN DUNN © 1970

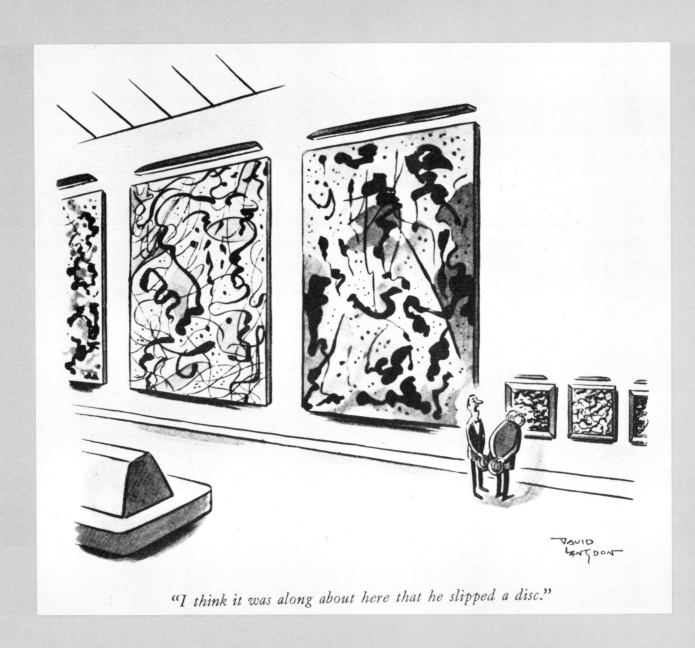

"*I think it was along about here that he slipped a disc.*"

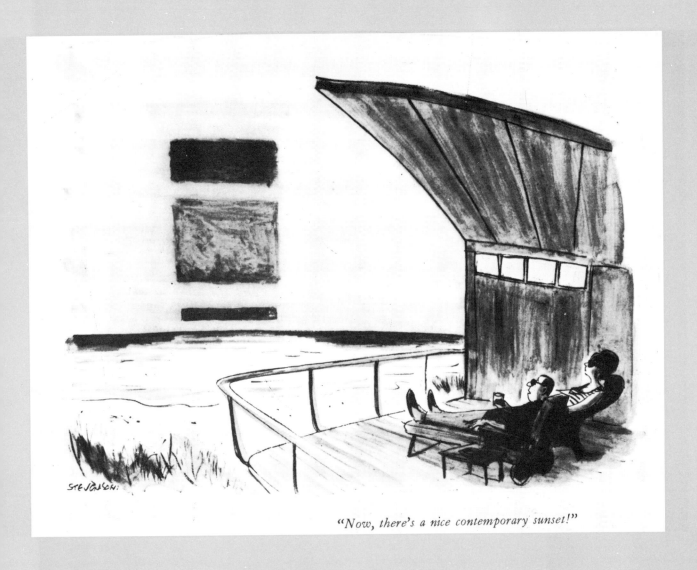

"Now, there's a nice contemporary sunset!"

85 *New Yorker* 29 Aug. 1964 STEVENSON © 1964

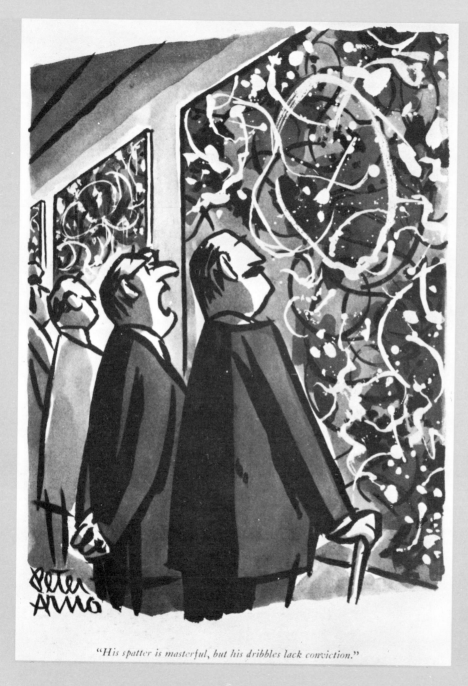

"His spatter is masterful, but his dribbles lack conviction."

86 *New Yorker* 26 Dec. 1953
PETER ARNO © 1953

87 *Punch*

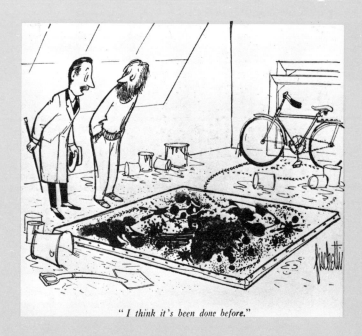

"*I think it's been done before.*"

88 *Punch* 27 May 1959

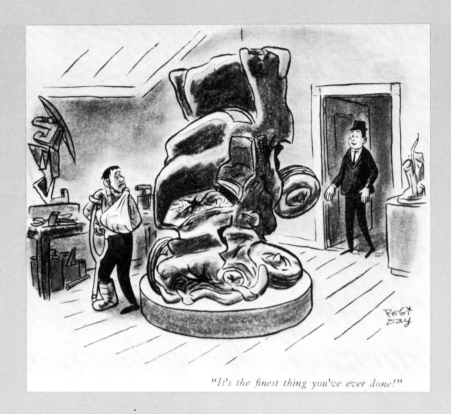

"It's the finest thing you've ever done!"

89 *New Yorker Art & Artists album*
ROBERT DAY © 1970

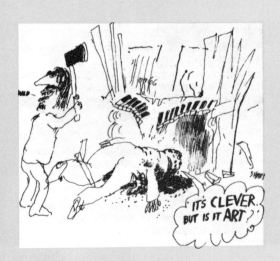

90 *Private Eye* 30 Sept. 1966

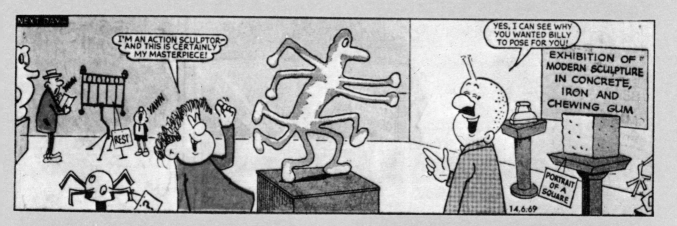

91 *Beano* 14 June 1969 Billy Whizz
© D. C. Thomson & Co. Ltd

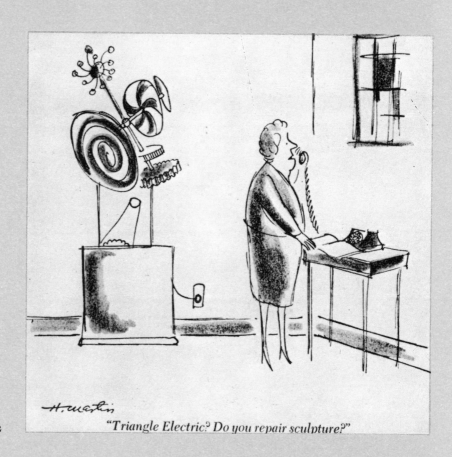

"*Triangle Electric? Do you repair sculpture?*"

92

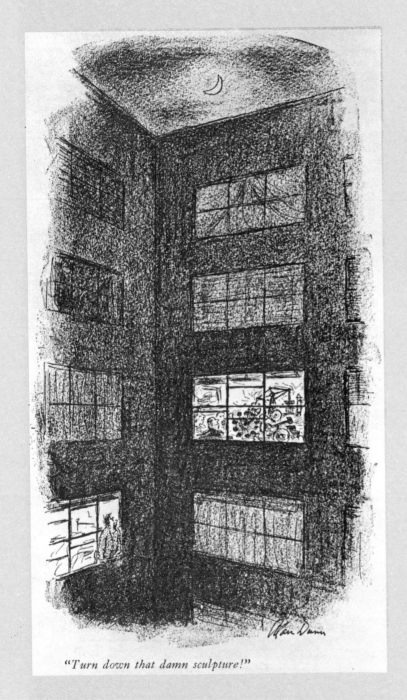

"Turn down that damn sculpture!"

93 *New Yorker* 18 June 1966
ALAN DUNN © 1966

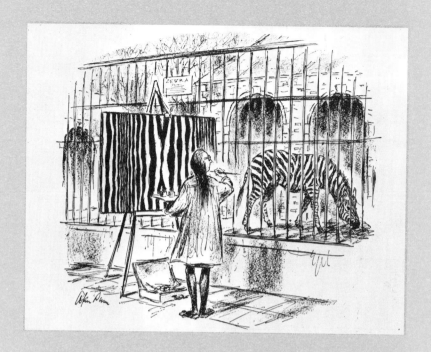

94 *New Yorker Art & Artists album*
ALAN DUNN © 1970

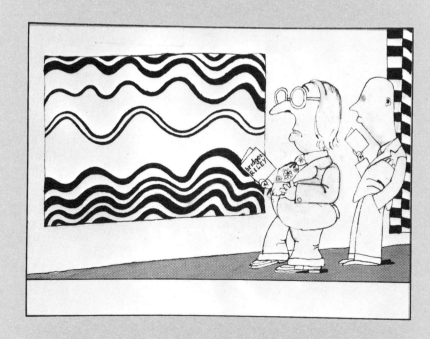

95 *Listener* 29 July 1971
Her paintings have always been my
bete noire et blanche
BARRY FANTONI

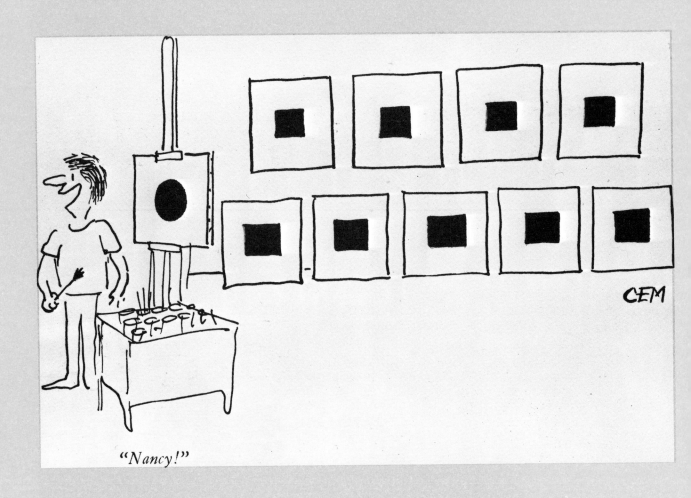

"Nancy!"

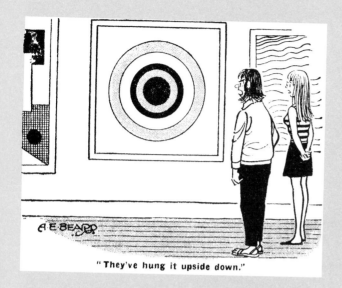

97 *Daily Sketch* June 1966
Associated Newspapers Group Ltd

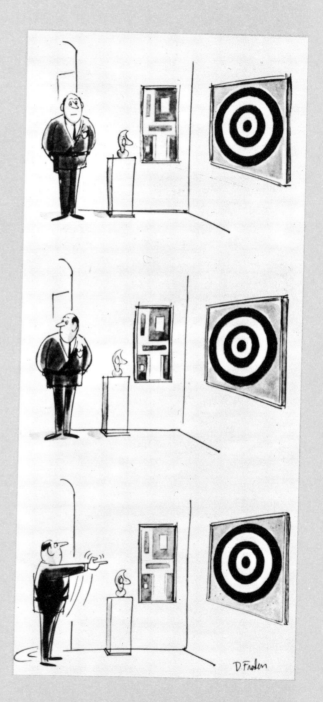

98 *New Yorker* 29 July 1967 DANA FRADON © 1967

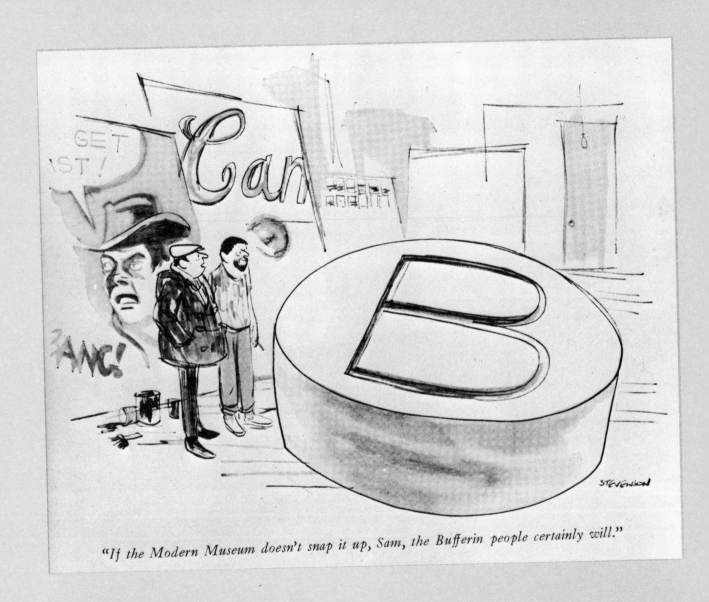

"If the Modern Museum doesn't snap it up, Sam, the Bufferin people certainly will."

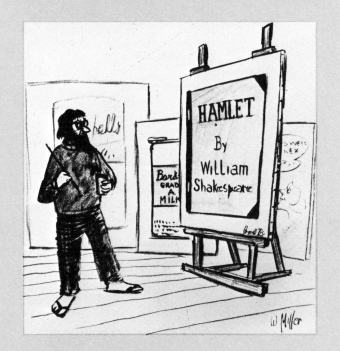

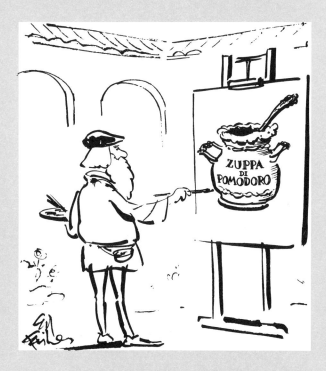

100 *New Yorker* 1 Aug. 1964
W. MILLER © 1964

101 *New Yorker Art & Artists album*
ED FISHER © 1970

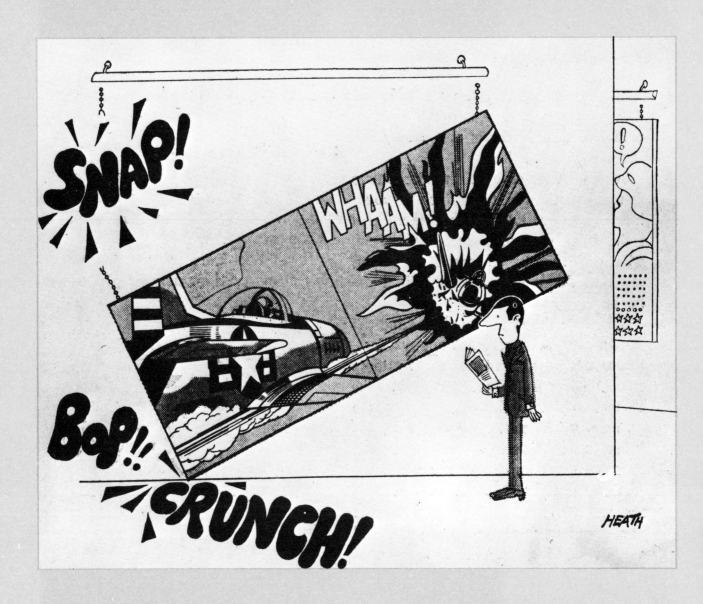

104 *London Evening News* 3 August 1971
Associated Newspapers Group Ltd

103 1973

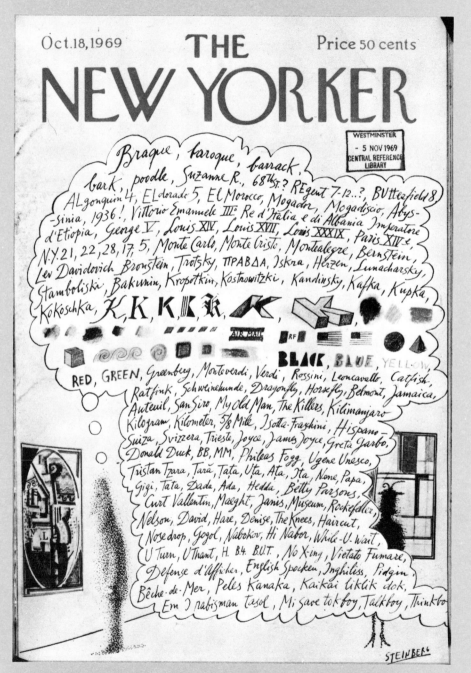

105 Steinberg © 1969

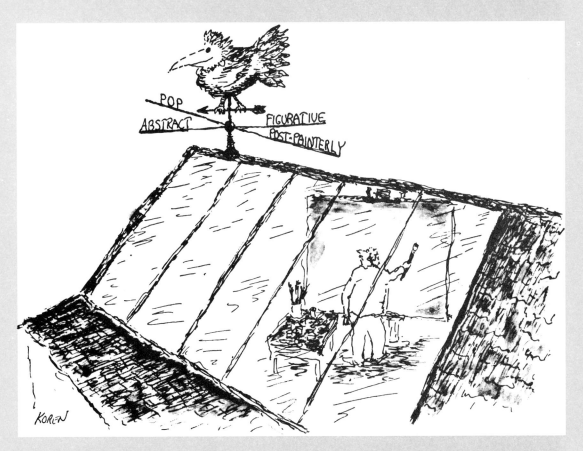

106 *New Yorker* 8 June 1968
KOREN © 1968

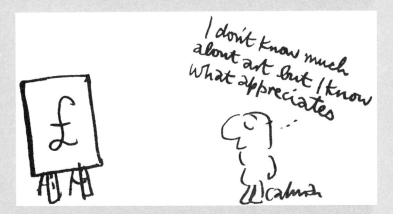

107

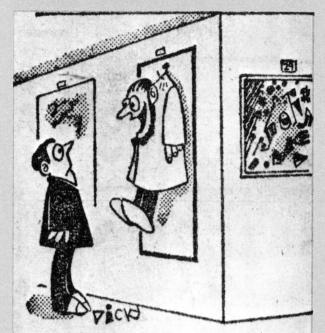

"... and then I thought to myself, what can I put in the exhibition this year?"

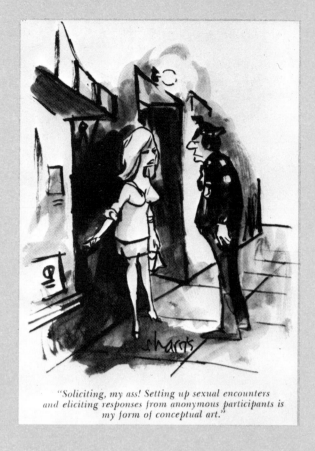

"Soliciting, my ass! Setting up sexual encounters and eliciting responses from anonymous participants is my form of conceptual art."

108 *Daily Mirror* 6 Jan. 1967
DICKY HOWETT

109 Reproduced by special permission of *Playboy Magazine* © 1972
SID HARRIS

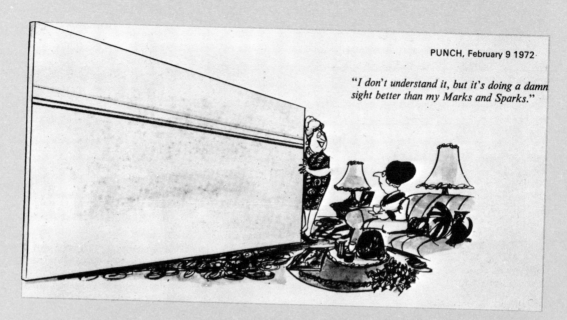

"I don't understand it, but it's doing a damn sight better than my Marks and Sparks."

110 MAHOOD

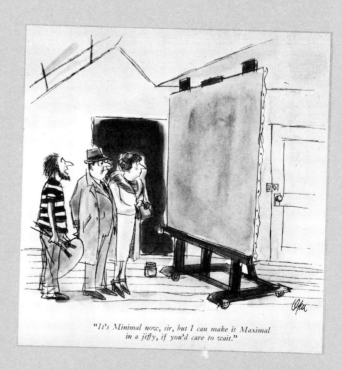

111 *New Yorker* 22 April 1972
OPIE © 1972

"It's Minimal now, sir, but I can make it Maximal in a jiffy, if you'd care to wait."

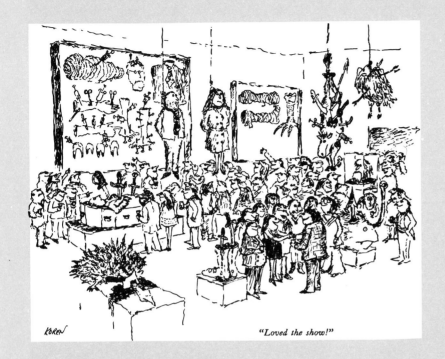

"Loved the show!"

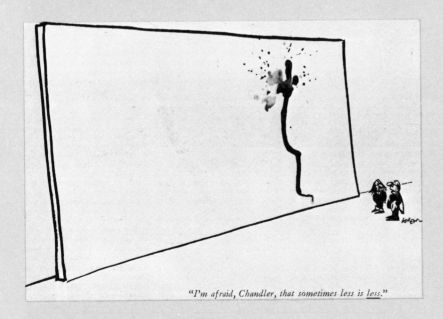

"I'm afraid, Chandler, that sometimes less is less."

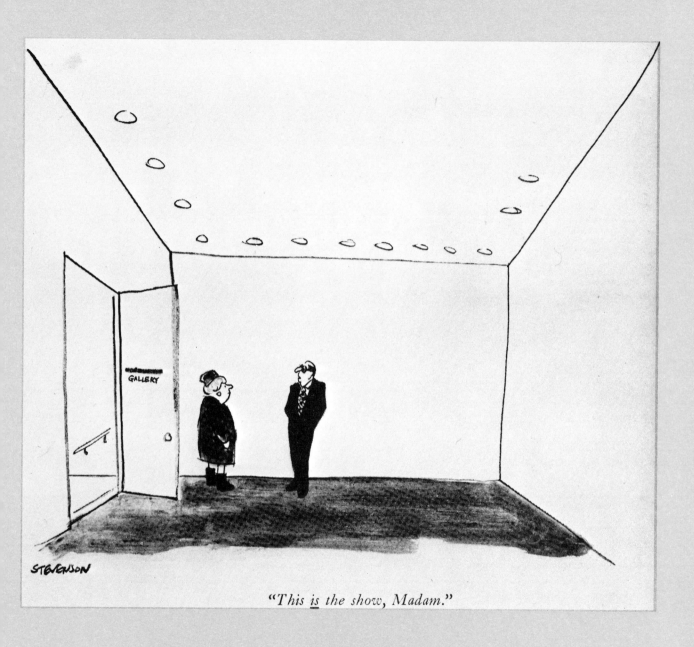

"*This is the show, Madam.*"

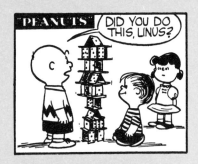

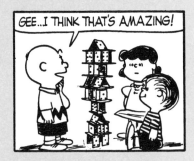

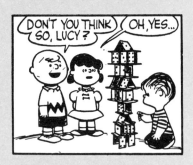

J. R. Glaves-Smith

Cartoons and the Popular Image of Modern Art

Like all artists who wish to be understood, the cartoonist is restricted by the limits of what his public will understand. Indeed, he labours under greater restrictions than most, because his work depends on instant recognition. If his jokes have to be explained, their impact is lost.

Both the uses and the pitfalls of cartoons as art-historical material are rooted in this basic property of the medium. Inasmuch as they must deal in the familiar, they can be taken as an index of what had filtered through to the type of people who formed the readership of a particular publication at any given time. (The nature of the readership aimed at should always be borne in mind. For instance, Osbert Lancaster will incorporate in his drawings intended for publication in book form references which would be lost on some of his *Express* readers.) The need for instant recognition leads to the exploitation of stock situations. This is why cartoon jokes have an internal development which need not bear much relation to what is going on in the world they purport to represent. This is particularly true in the case of modern art although it is certainly not unique in this respect. Many of the cartoons in this exhibition depict modern works unlike any ever created. One can claim that there are distant antecedents in the art of Epstein, Picasso or Henry Moore, but the style has been imitated from other cartoons rather than the works themselves.

When we move to the more difficult area of assessing attitudes, the inbred nature of the cartoon joke presents us with still greater problems. Jokes about starving artists in garrets relate to existing conventions of the cartoon almost as much as do little green men from a spaceship saying 'Take us to your leader'. This is not, of course, to say that artists never starve in garrets or, more to the point in this context, that the public do not see them as doing so. It simply means that a cartoonist working on this theme does not need to refer to any concept, be it true or false, of the subject beyond that which has already been established by his predecessors. This begs the question of why certain cartoon situations crop up again and again. Is it because they represent the public's idea of the truth, however inaccurate it may be? On the most literal level, this is demonstrably not the case. Everybody knows that the first of the cavemen can never have met the last of the dinosaurs but this has not prevented cartoonists from E.T. Reed onwards making inventive use of the confrontation. Yet, on another level, there is truth in the image. With the exception of precocious schoolboys and other specialists in the field, most of us find it hard to differentiate between the vast wastes of prehistory. While we do not really believe that early man hunted the brontosaurus, we tend to see them as part of the same world, distance having marred our powers of making distinctions. What the cartoonist does is to make a clarified image of our own confusions.

There is an analogy here with the treatment of modern art. In this country, at least, the public is presented with a fragmentary, incomplete view by the Press. It only receives a large body of information and comment when some event makes a large,

usually scandalous, impact. One thinks of Epstein's 'Rima' in 1925, the controversial Picasso exhibition in 1946, and more recently the purchase of Lichtenstein's 'Whaam!' by the Tate. It is hardly surprising that the cartoonist has created an image of modern art which horrifies the art historian as much as his cavemen must horrify the palaeontologist. The parallels between the two genres of the cartoon cannot be taken too far. The big difference is that cavemen and dinosaurs are safely dead and a static subject for the cartoonist, while modern art is a constantly changing phenomenon. Therefore the cartoon image of it changes too. The speed with which this happens is in direct proportion both to the sophistication of the publication and to the amount of publicity the changes receive. For instance, the first Pop Art cartoon in *The New Yorker* appears as early as 1962 (No. 99).

A certain satirical force is inevitable in any humorous comment on a current phenomenon. It is hardly necessary to point out that most of the cartoons in this exhibition are done from a distinctly anti-modernist viewpoint. 'My old man sees things like that too, but thank God 'e don't drore 'em,' says the charwoman, but 'things like that' are the product of the cartoonist's imagination rather than the artist's. One comes to the stage where it is somewhat beside the point to talk about cartoons as a reflection of public attitudes to art. The cartoons create an image which supersedes the real one. As evidence of this, one could cite the contemporary response to the first London Futurist exhibition in 1912. Cartoon images, often drawn with no more than cursory attention to the works themselves outnumber illustrations of the actual paintings in the daily Press which published cartoons, at that time

only the *Daily Mirror* and the *Daily Express*, and equal them in the more sophisticated illustrated magazines, such as *The Bystander* and *The Sketch*.

Inevitably, there is an even greater bias in favour of the cartoon image at times when little genuine advanced art is on view. It is surprising that cartoons about the subject appear perpetually during the 1920s in both *Punch* and *London Opinion*. During these years there was little opportunity to see in London even the work of Matisse and Picasso while the Surrealists were completely unknown. Apart from the controversies over Epstein, there was no event comparable in its impact on the public to the Post-Impressionist and Futurist exhibitions before the war. A solitary Picasso exhibition at the Leicester Gallery in 1921, which included some Cubist works, does not seem to have created much stir outside the art world. Nevertheless, the cartoons continue to depict Cubist and Futurist paintings. These are not parodied in such a form as to suggest any great knowledge. There is none of the observation of the art world which makes the best of *The New Yorker* cartoons such devastating satires. The mere existence of cartoons cannot therefore be taken as an indication of public awareness.

The British cartoons of the twenties reflect a situation in which modern art was still an issue but there was insufficient material for the controversy to be sustained on a particularly informed level. Throughout this period there were books on advanced trends in European painting published in London. Even those which were on the whole in favour of the new developments, such as Charles Marriot's *Modern Movements in Painting* (1920) and Frank Rutter's *Evolution in Modern Art* (1926) were less than whole-hearted in their

enthusiasm for Cubism. There was a tendency to regard it as a purely experimental phase which prepared the way for the classicism of Derain and Dod Prockter. It is symptomatic that the latter book contains a howler confusing Monet and Manet which survived uncorrected into the 1932 'revised edition'.

Also published were books devoted to attacking modern art. These are very badly informed. E. Wake Cook's *Retrogression in Art*, published in 1924, is immediately inspired by the admission to the Royal Academy of such an advanced artist as Augustus John. There is an attack on the cult of Cézanne and Cubism – 'the art for blockheads'. A theme running through this book, common to many attacks on modern art in the period, is the link claimed between advanced art and Bolshevism. 'The Futurists tried to out-Lenin Lenin in Bolshevik destructiveness and wished to destroy all the old Masters.' A further common charge which appears in this book is that the acceptance of modern art is mainly the result of the machinations of dealers. 'Seeing unsaleable works by a likely man (Cézanne) they corner them and then start a campaign of indirect advertising, even having "Histories" written for the purpose of having incompetent works incontinently claimed as the greatest masterpieces of the time.'

The themes of *Retrogression in Art* are reiterated in a more lighthearted form in W. Hugh Higginbottom's *Frightfulness in Modern Art*, published in 1928. Here the boosting of advanced art is blamed more on the critic than the dealer. According to him, the eccentric opinions of the critic are widely publicised at the expense of those of artists competent to judge the modern movement at its true worth. The significant thing about this book in relation to the cartoons of the period is that, in spite of its late date, apart from passing references to Brancusi, the art attacked is basically that seen in the pre-war exhibitions and which had had no major London showings since. In this the book is similar to most British cartoons of the twenties.

Thematically, however, there is little connection between writing attacking modern art and the cartoons. In cartoons we find that the advanced artist, so far from being in a privileged position, is very much the underdog. He is always behind with his rent and his work is the constant butt for witty jibes about its ugliness or imcomprehensibility from the general public, who show an air of amused common sense (No. 37). The split between verbal attacks and those in cartoons has much to do with the style of humour of the period. The most common form is basically an illustrated wisecrack. Particularly biting satire, as had appeared in the Great War attacking Germans and conscientious objectors, is almost unknown. The more serious accusation that advanced art was allied to a subversive international conspiracy would be out of place in this context.

For a cartoon which embodies the deeper fears behind the dislike of innovation in art we must turn to a more serious example, Bernard Partridge's 'For this relief not too much thanks', published in *Punch* in June 1925. Partridge had considerable personal feelings about Epstein's 'Rima'. In November of the same year in company with Hilaire Belloc, Sir Arthur Conan Doyle and the President of the Royal Academy among others, he signed a letter to the *Morning Post* demanding the removal of the work in question. His Epstein cartoon was the serious comment on current affairs which, then as now, *Punch* published every week as a kind of editorial. Later more light-

hearted parodies were to appear which had none of the undertones discernible in the Partridge drawing, unusual for its period in giving vent to the feeling that there was a connection between modern art and the importation of revolutionary ideas from abroad. This is made quite explicit by the saying 'Kamarad' attributed to the Epstein sculpture. The idea has already been noted as a theme of Cook's book and turned up in Press items on modern art. For example, there is the leading article published on the 14th June 1923, by the *Morning Post*, a newspaper which was to be particularly virulent in its attack on Epstein's sculpture.[1] Entitled 'The Bolshevik in Art', it attacks the influence of foreign tendencies. 'It is no use trying to cast the blame on foreign eccentrics, Gauguin and Matisse and the rest of the Bolsheviks in art. They have nothing to do with England and English artists have never yet achieved any good by imitating foreign fashions which are derided even in their country of origin.' Partridge's cartoon therefore directly confronts what was seen as a subversive import with a symbol of English traditional art. Of course, 'Eros' is much more derivative of continental sources than the 'Rima', but this does not affect the message of the cartoon. Epstein's name was enough to brand him as utterly un-English. As Colonel Jones asked in the House of Commons, 'Is the Minister aware that it has been suggested that the sculptor, owing to inadequate knowledge of the English language, thought that he had to produce a sculpture dealing with birds and erected a scarecrow?' (Laughter.)[2]

Throughout the twenties and early thirties the work of Epstein stood for all that was outrageous in modern art. The work of Picasso, Matisse and Leger was illustrated in books[3] but they were little more than names to the general public. The work of Nevinson was better known, largely on the strength of the impact made by his war pictures when they were shown at the Leicester Gallery in 1917. The *Punch* cartoon of the war veteran in the gallery (No. 34), which refers directly to this exhibition, represents a most uncharacteristic response. Nevinson's own scrapbooks are full of material published at this time which testifies to the extent to which men who had been at the front felt that these paintings were a truer record of their experience than either the official photographs or the more academic paintings of the subject. As one letter from a soldier in the *Saturday Review*, replying to an attack on the paintings, said: 'Sir, Don't suspect us of condoning Cubism . . . But Nevinson is another matter. At his best, he may be allowed to have justified even that appalling convention.' Although the public seem to have forgotten fairly quickly the message that Cubism need not necessarily be insincere, Nevinson remained a public figure. It was widely reported when he asked that one of his best known works 'La Mitrailleuse' be removed from the Tate Gallery because he considered it 'the worst picture in the world', an event which attracted more than one cartoon (No. 35). The cartoon image of modern painting developed during the twenties relates as much to the work of Nevinson as anybody else.

The provincial attitude which made Epstein and Nevinson appear as the height of modernity received a severe blow with the publication of Herbert Read's *Art Now* in 1933. The book's stance was more uncompromisingly in favour of advanced art than that of publications on the same subject which had appeared previously, while a greater quantity and variety of work was illustrated than ever before, including for the first time the

works of the Surrealists and the German Expressionists, offering a mine of new material for the cartoonist to parody. Derrick's cartoon of the Moderns attempting to gatecrash the Royal Academy, which appeared in January 1934, is almost completely derived from different plates in the book. A significant exception is Epstein's 'Rima' which appears near the barrier towards the left of the drawing. The sculptor's work was not featured in Read's book, but had become synonymous with modern art so that it could hardly have been omitted from the cartoon. Directly beneath the 'Rima' is a figure that may well have the distinction of being the first ever cartoon of a Henry Moore. It is taken from a drawing of 1931, plate 37 in the original edition of *Art Now*. Derrick can hardly have known what he was starting.

A more important impetus for modern art cartoons came in June 1936 with the *International Surrealist Exhibition* in London. The newspapers gave considerable coverage to the event. They were particularly intrigued by the appearance of a model with her face covered in flowers. The reaction was on the whole one of amused tolerance, an attitude perhaps unwittingly encouraged by Herbert Read's introduction to the catalogue which relates the movement to the very English tradition of William Blake and Lewis Carroll. It was left to the *Studio* to express real moral indignation: '. . . the type of imagination shown is repellent. The exhibition in London abounded in literal monstrosities and cheap horrors. They may be ascribed to a deluded amateurism, a striving for notoriety or genuine craziness.' None of this response was reflected in the *Punch* cartoons arising out of the exhibition and after the war it became apparent that the movement which had identified itself with revolution far more than those which had been accused of it had become a synonym for little more than whimsical fantasy. In the late forties there appeared in *Lilliput* a series of stories by Maurice Richardson entitled 'The Adventures of Englebrecht', which were published in book form in 1949. These deal with the Surrealist Sporting Club and are more concerned with a light-hearted approach to the occult than with the psychoanalytic concerns of the real group. There is a character called Salvador Dali but he bears little resemblance to the man who had created such a sensation in 1936 by giving a lecture in a diving suit.[4] The only link with the real movement is the constant leitmotif of clocks. Englebrecht's business is boxing with them, a fairly obvious derivation from Dali's soft watches, which were a well known image in 1946 as can be seen in the *Strand Magazine* cartoon (No. 51).

Brilliant as it is, this cartoon is an instance of one of the saddest facets of public response to modern art. A particular symbol or even a word can become lodged in the mind at the expense of the real substance behind it. This is a situation not unique to Britain, for instance, there is Le Charivari's savage cartoon about the Balkan atrocities, 'Ah, les beaux Modèles pour Rodin!' (No. 12). The mutilated corpses look nothing like Rodin sculptures. He had simply become identified as the sculptor who hacked off limbs, just as for many people today, Henry Moore is the man who puts holes in women. Such a situation is a gift for the cartoonist because something as obvious as this is sure of a response.

However, we should not condemn the complete race of cartoonists. There have been those who really looked at the art they were satirising. E.T. Reed's 'Britannia à la Beardsley' (No. 4) is

almost as good as the real thing and less well-known but in the same spirit of observant satire are Syke's pastiches of Futurism (No. 24). To turn to France, *La Vie Parisienne*'s cartoonist beautifully and wittily encapsulated the sense of Matisse's 'Dance' and 'Music' (No. 14). It is worth remembering that he was heir to a tradition of satire going back to the early nineteenth century in which the most academic works were no more exempt from ridicule than the most advanced.[5] This form came out of a situation in which art was a natural subject for wide discussion and did not require the scandals which were necessary to arouse interest in Britain.

In both countries new advances in art were taken less for granted than they are inclined to be today. Is it possible that through openmindedness we have lost some of the excitement in the new that comes when it has to struggle for acceptance ?

[1] Epstein, *Let there be Sculpture*, 1940.
[2] *Evening Standard*, 25 May, 1925.
[3] Rutter, op. cit. Pach, *Masters of Modern Art*, 1925
[4] Ray, *The Surrealist Movement in England*, 1971.
[5] Roberts-Jones, *De Daumier a Lautrec*, 1960.